EPILOGUE

FOREWORD

When we set out to create Epilogue, we knew we wanted to be more than just a random illustration book you can find – and possibly ignore – on bookshelves. As artists, we've always been inspired by the works produced in the United States, Europe and Japan… movies, video games, comics and anime… we always looked to them to draw our lines and define our styles and crystallize our ideas. Over recent years, however, creative minds in the region started leaving their mark on the art world, and we thought, "Hey, maybe we could be an inspiration to others too."

We reached out to over 32 illustrators, concept artists, designers, game developers and animators scattered across the region, and selected samples of their work to be featured in Epilogue.

Through this book, we want to showcase the talents the Middle East has to offer and raise awareness regarding our budding community and just how much we're capable of doing and creating. A small step, perhaps, but one that will hopefully pave the way for the expansion of this industry in our countries.

EPILOGUE TEAM,
Ibrahem Swaid
Joumana Ismail

EPILOGUE

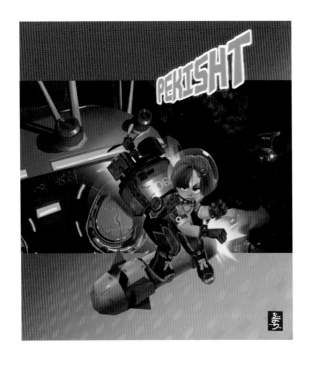

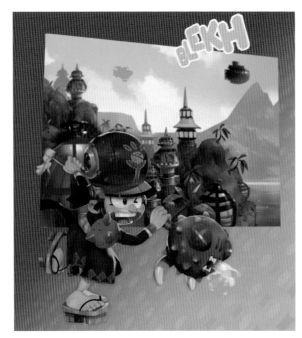

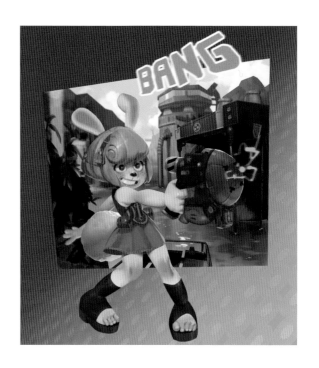

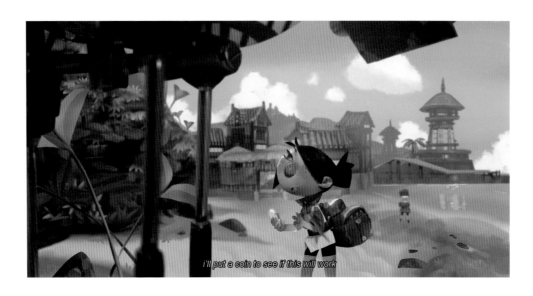

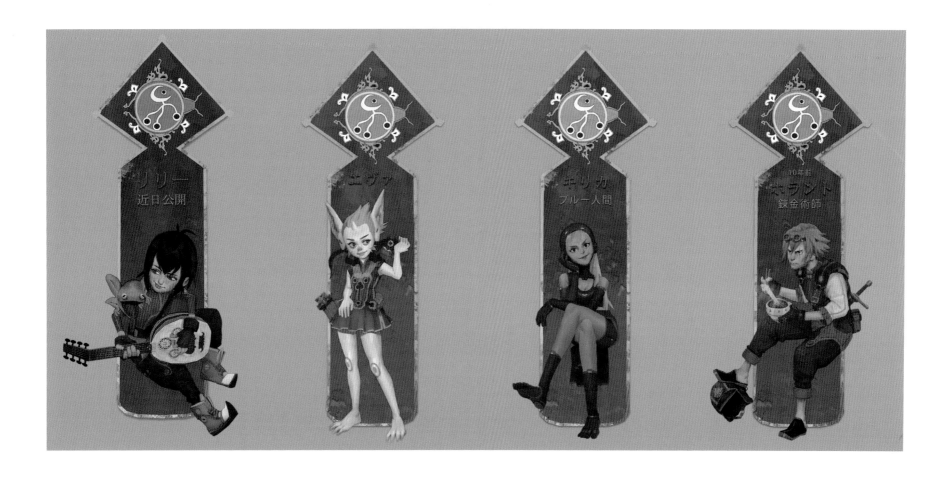

AHMAD ADEL BEYROUTHI

As a kid, drawing was always my outlet and hobby, but now as an adult, I get to call myself a professional concept artist and character designer. I have worked with multiple game studios, including Ubisoft, and plunged myself headfirst into any and all art forms. Yet I know I've still got a long way to go; after all, you may never become a master at your craft, but you can always get better at it.

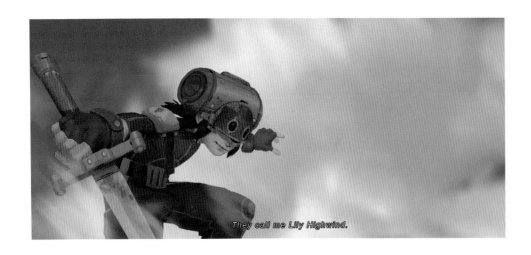

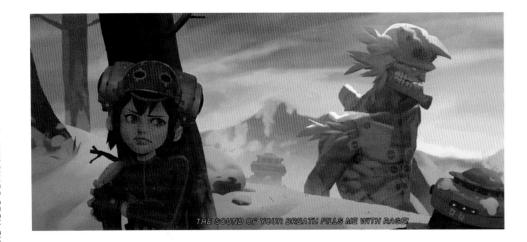

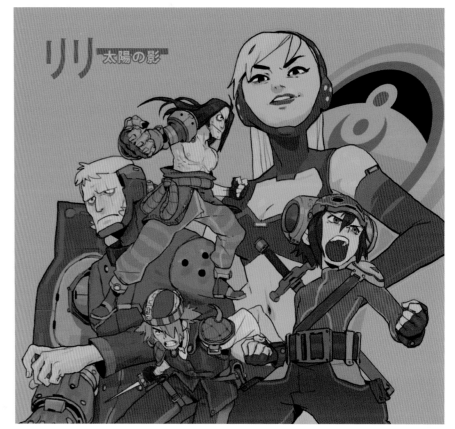

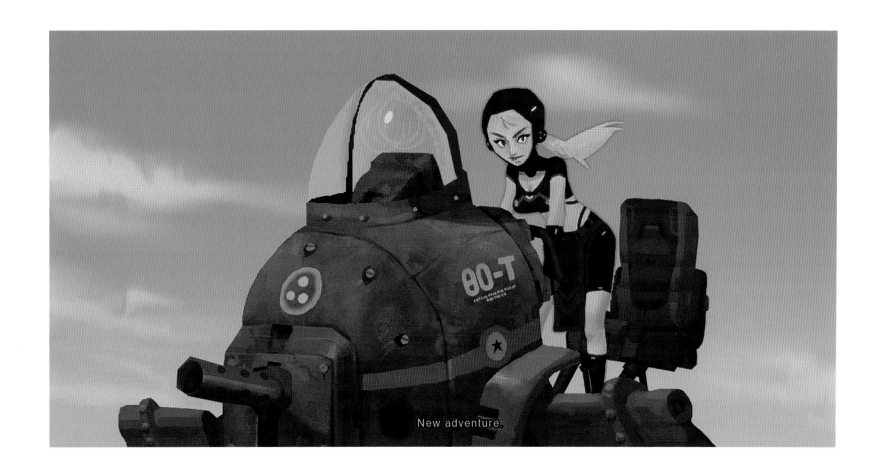

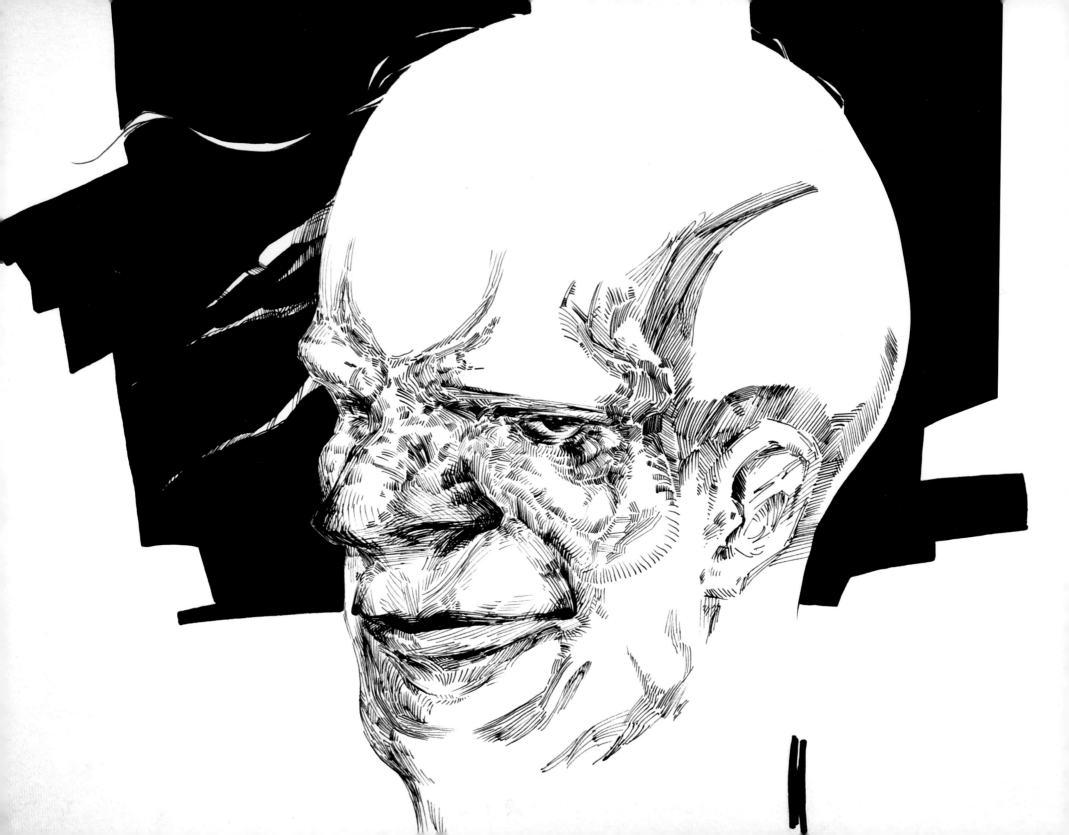

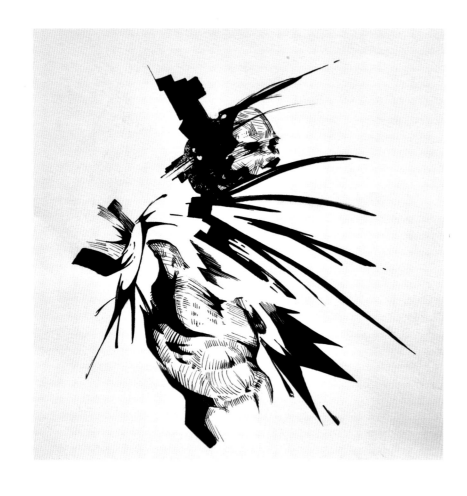

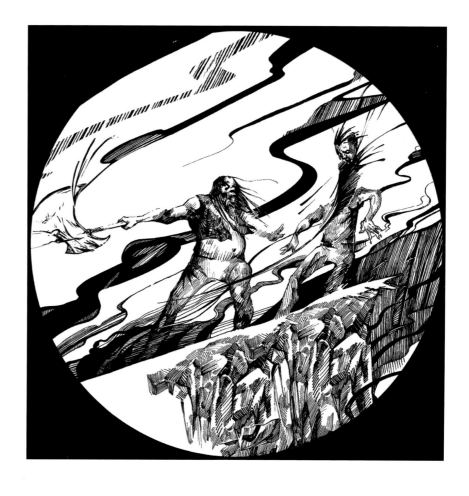

AHMAD MANAR LAHAM

After graduating with an MFA in Traditional Illustration from the Academy of Art University in San Francisco and a BFA in Fine Arts from the University of Sharjah, I set about "baring my soul", as one would say, and displaying my work for the world to see in a number of venues across the United States, Canada and the UAE, before final settling down to work for the University of Sharjah as an instructor at the College of Fine Arts and Design. I am fascinated by the human form, as evidenced by my art, which covers a wide range of relevant linear and tonal expressions of shape and space.

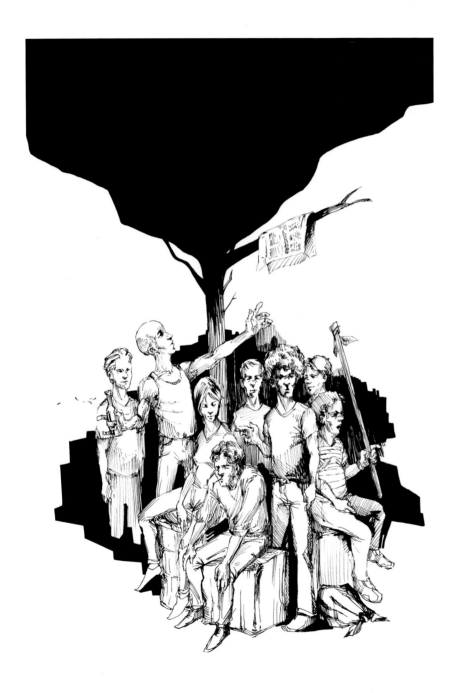

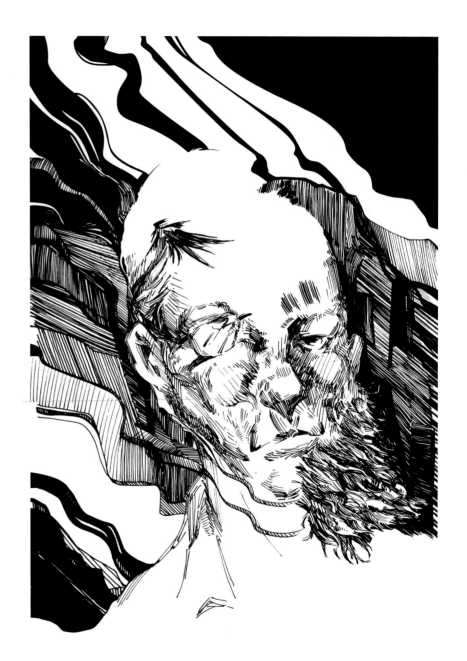

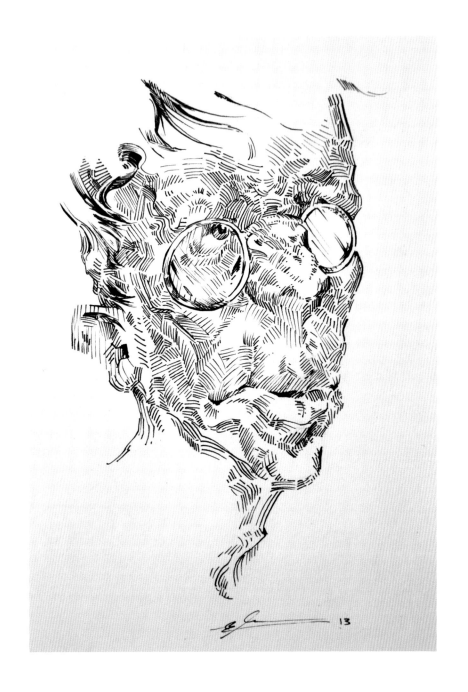

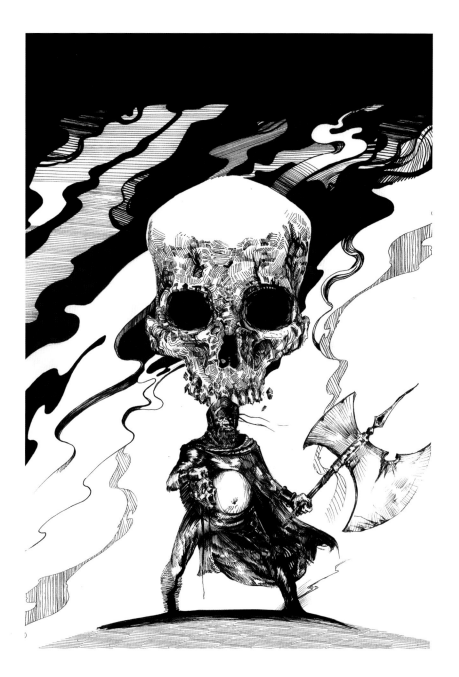

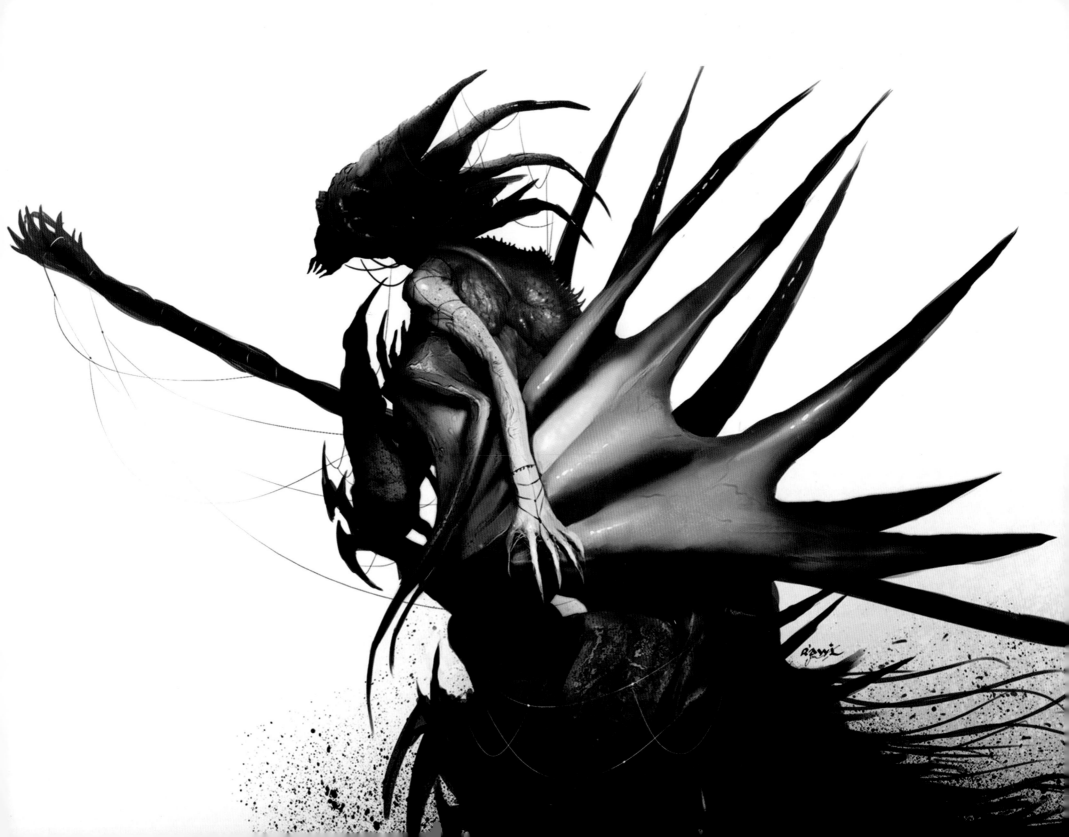

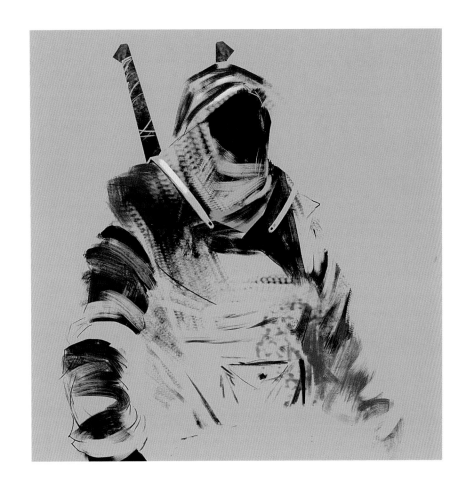

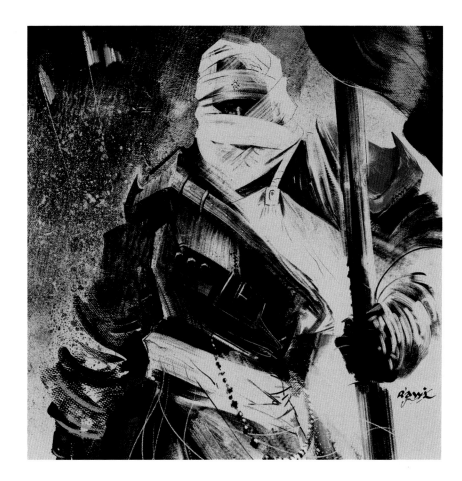

AHMED RAWI

I was born in Baghdad in 1988 and Studied graphic design in Amman. In 2009, I started working on feature films and mobile games as a 3D artist (texturing and sculpting) side by side with my freelance concept art and illustration works for games and cartoon TV series. I'm a lecturer, I teach post production and digital design. I work between 3D and 2D softwares, which helped me to create a good variety of styles and ideas. My main goal is to create art that people can enjoy, and to learn as I go.

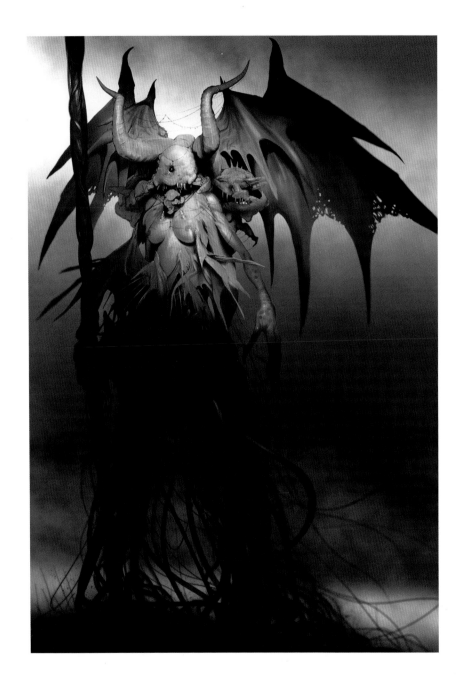

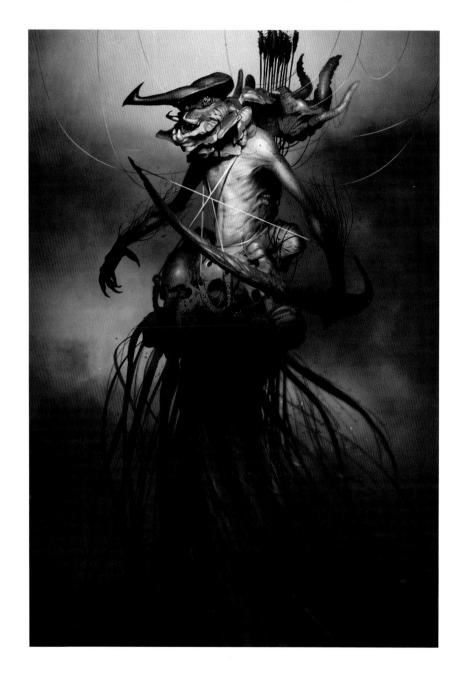

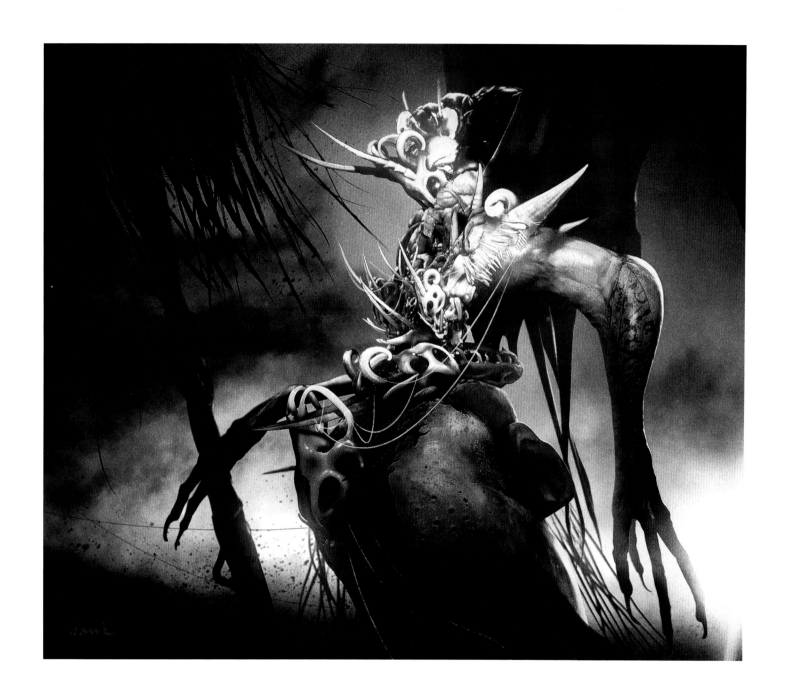

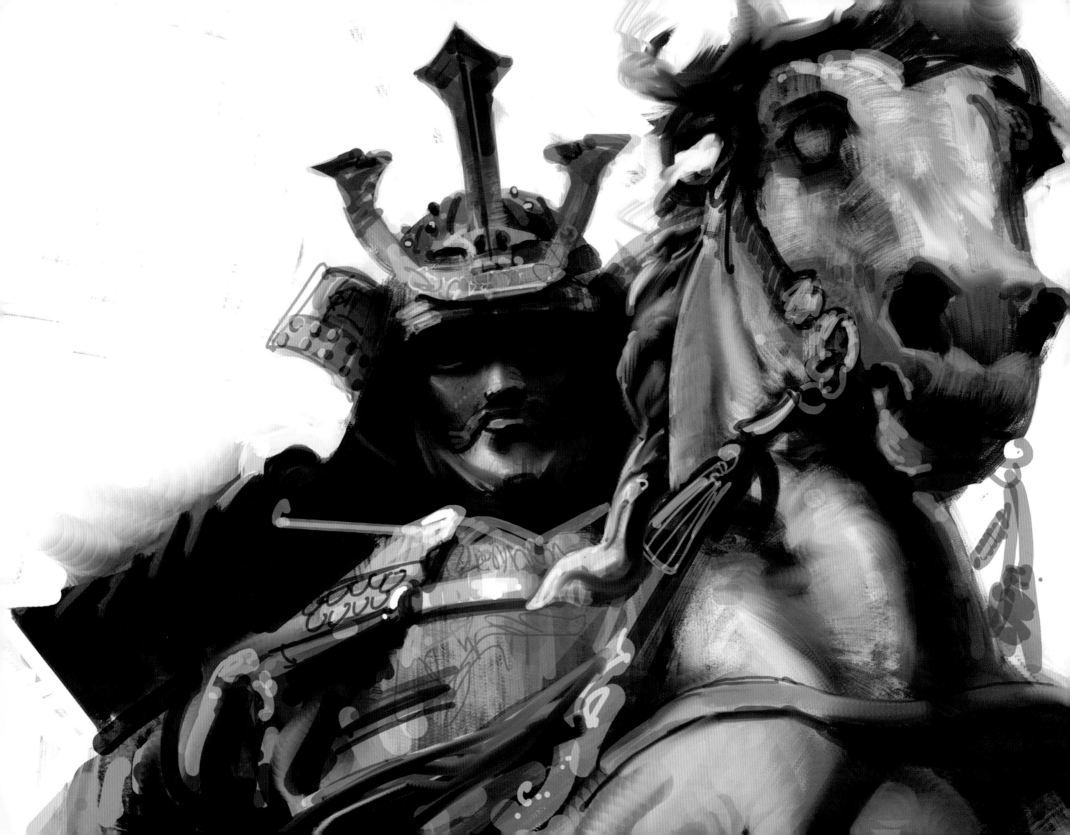

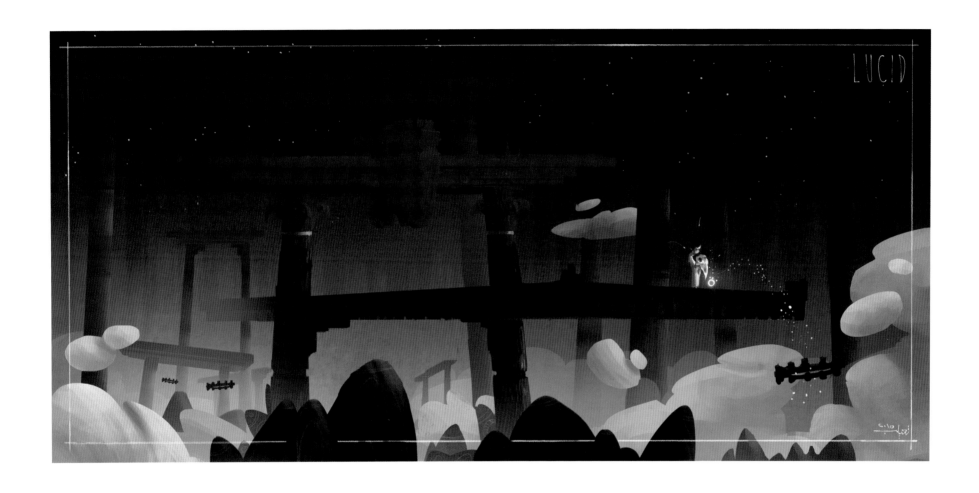

AHMED TEILAB

I'm a concept artist working in the film and animation industry, currently posted as an art director for Aroma Productions. Addiction to movies, video games, comics, brilliant storytelling and music comes with the territory, and I'm a huge fan of the Lord of the Rings trilogy and the Game of Thrones series. I also dabble in martial arts on the side, so hey, if my career as a concept artist doesn't kick off, I can always become a martial "artist". Get it? No? Ah, never mind.

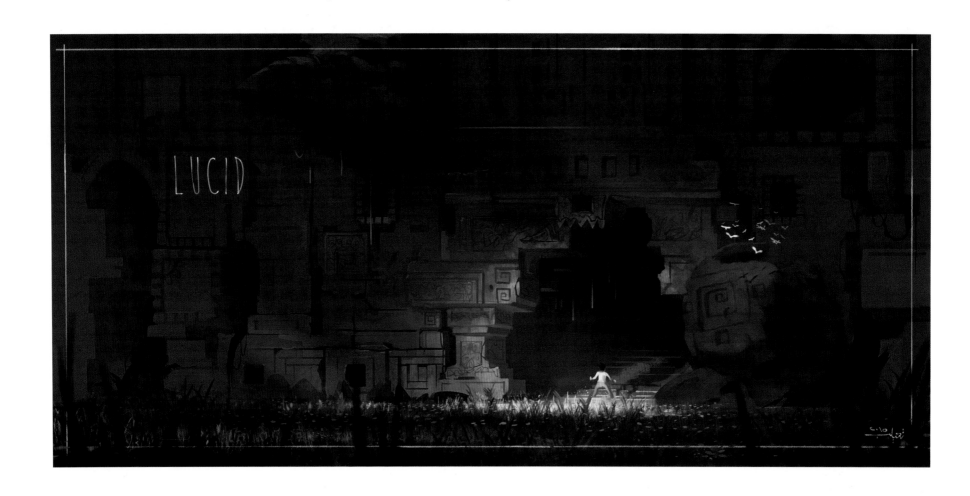

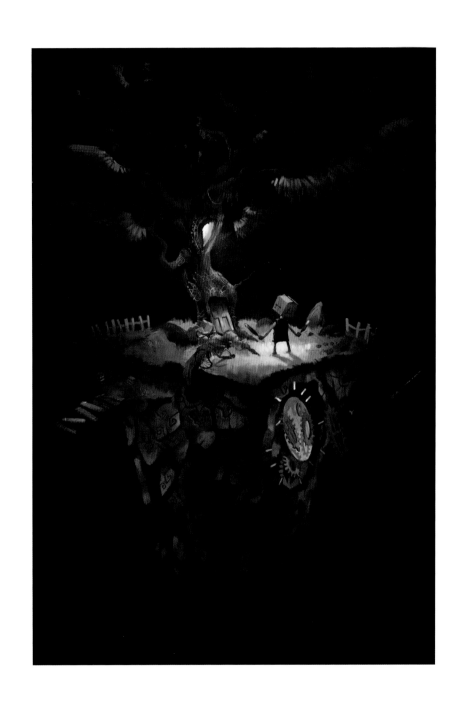

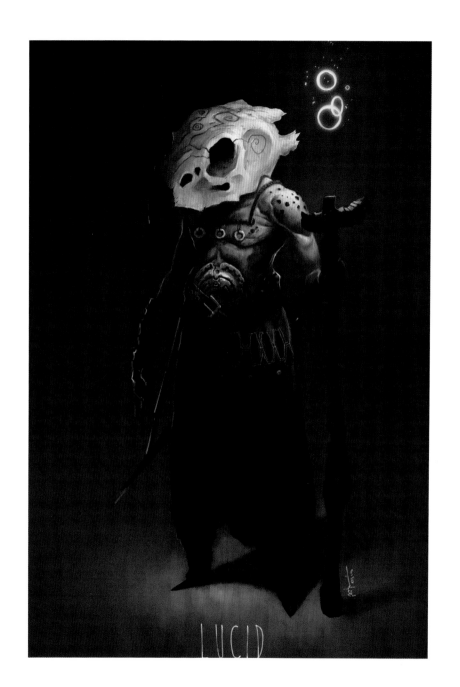

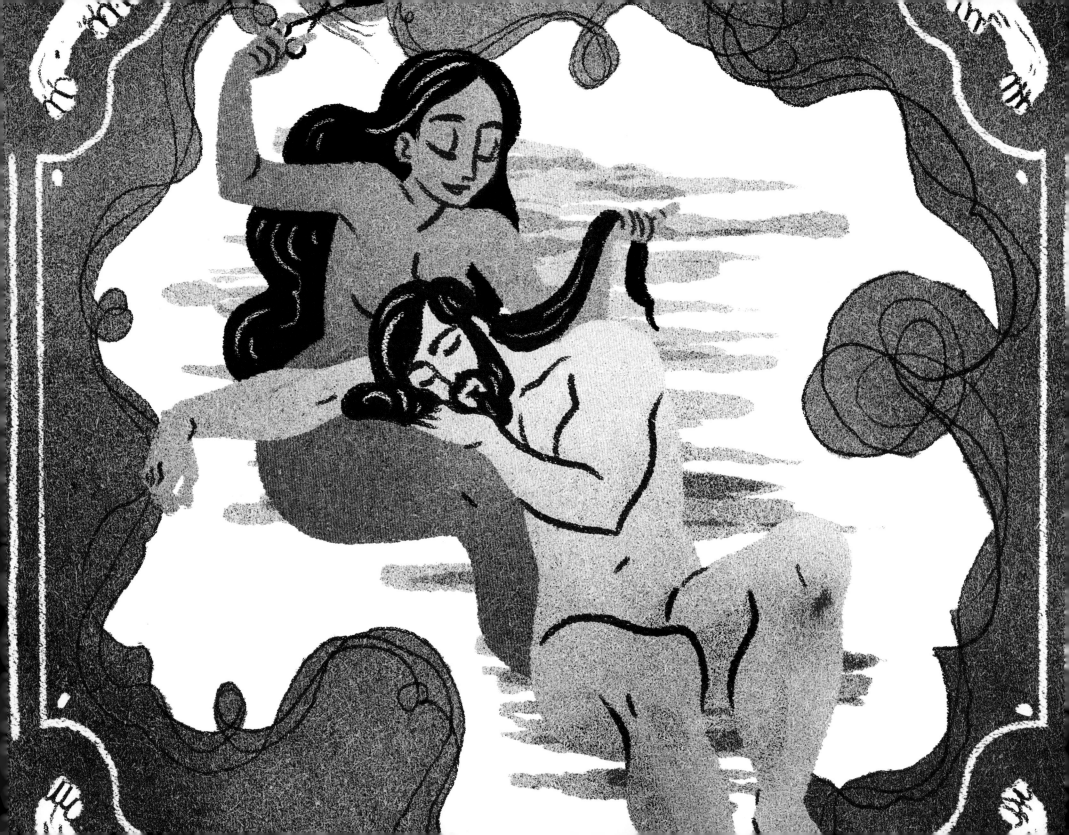

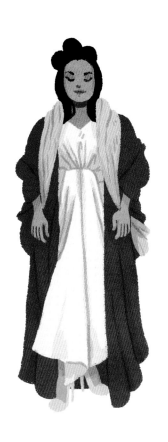
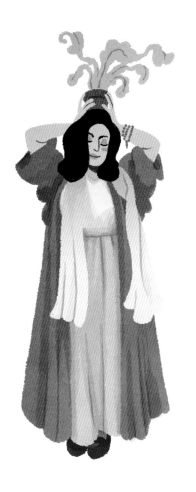
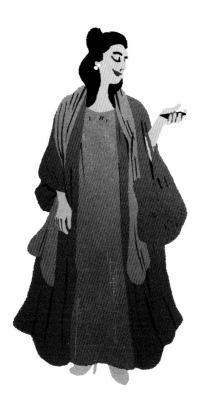
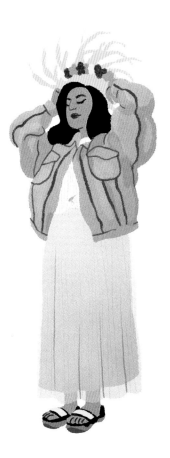

AZIM AL GHUSSEIN

I am an illustrator and cartoonist based in Dubai. I love a good story, and I've heard plenty from the various ethnicities in the UAE; in fact, most of my comics are inspired by international folklore. I'm not an elitist when it comes to art, and mine covers everything from Arabic myths to character illustrations from Disney films and shows like Game of Thrones. When I'm not drawing, you can find me either watching weird artsy films or reading anything but superhero comics.

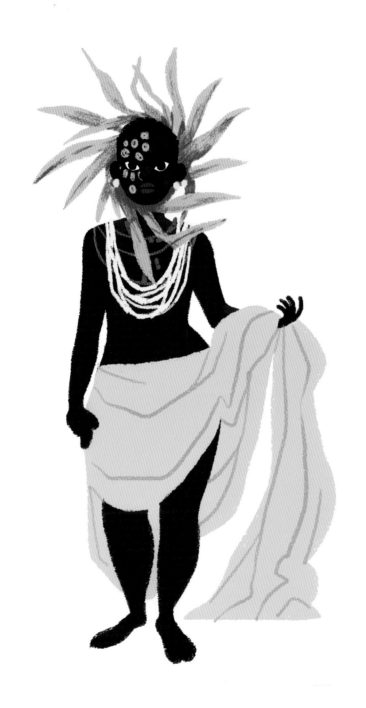

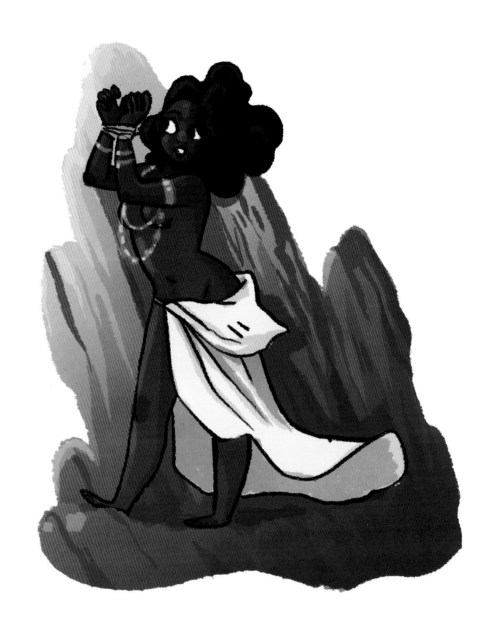

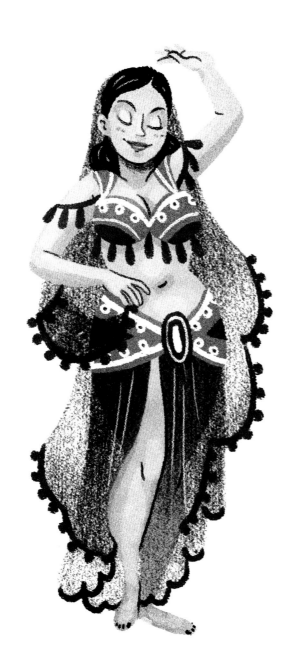
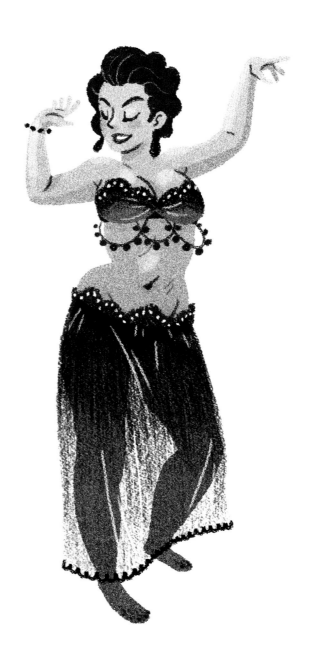

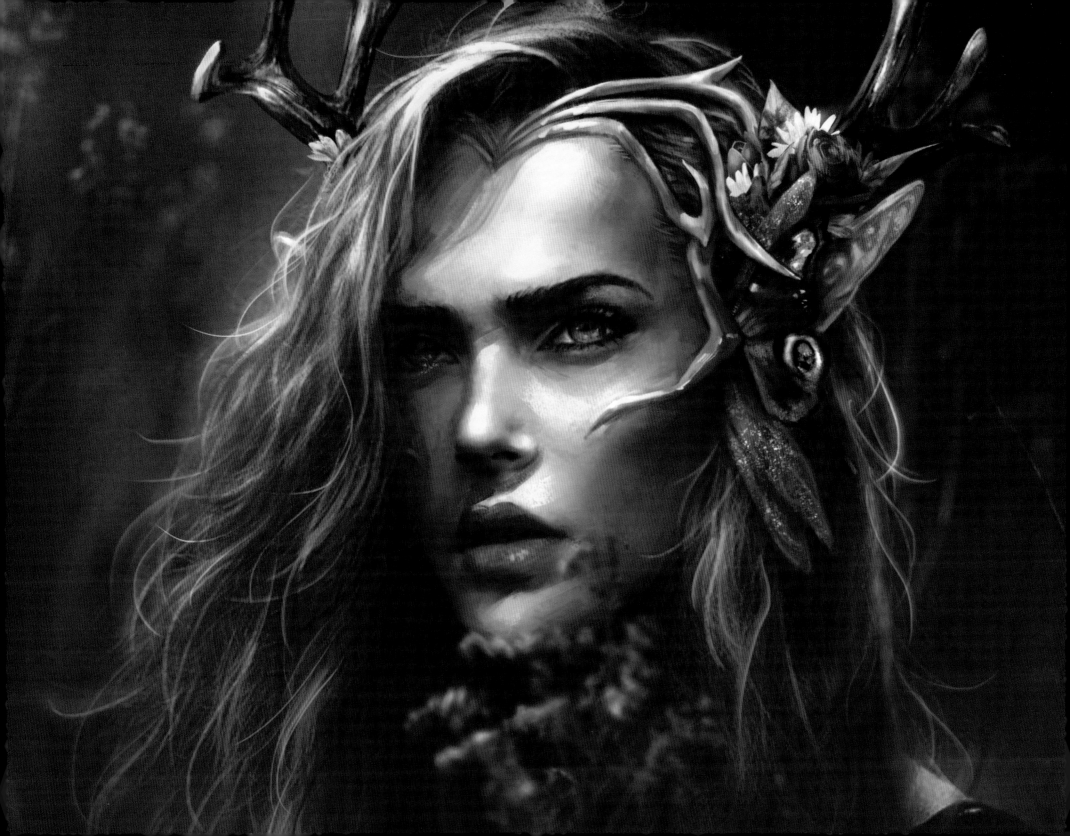

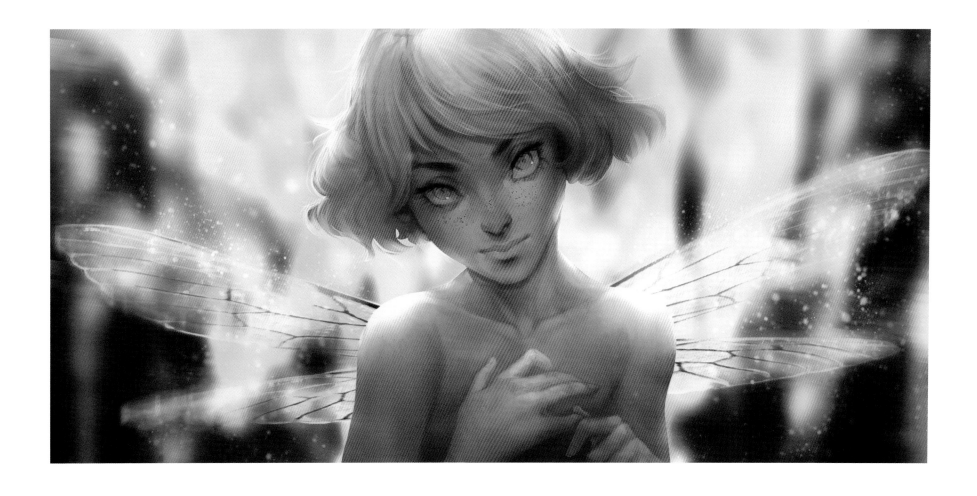

AMEERA SHEIKH

I've always considered art to be a space where I'm allowed to explore, wander, learn and impact, and though I've been in this field for over 10 years now, I still find something new to learn every day. After graduating with a BA in Visual Design, I worked at Ubisoft Abu Dhabi as a character junior artist for a year, during which I was involved with numerous projects and many inspiring people. I have since moved back to my hometown of Jeddah to continue as a freelancer.

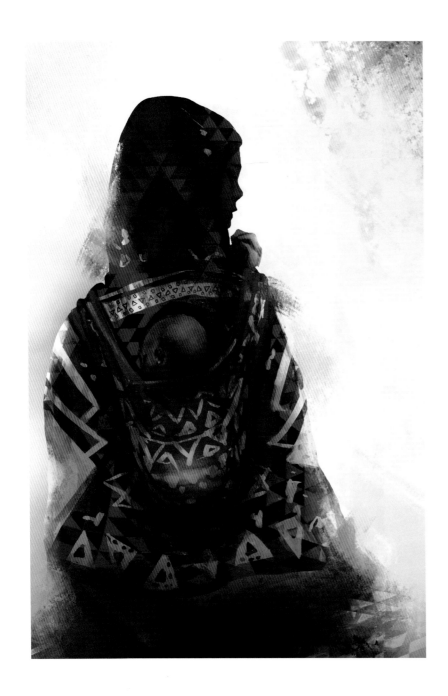

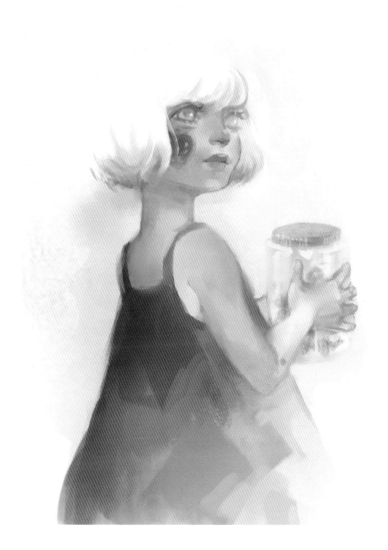

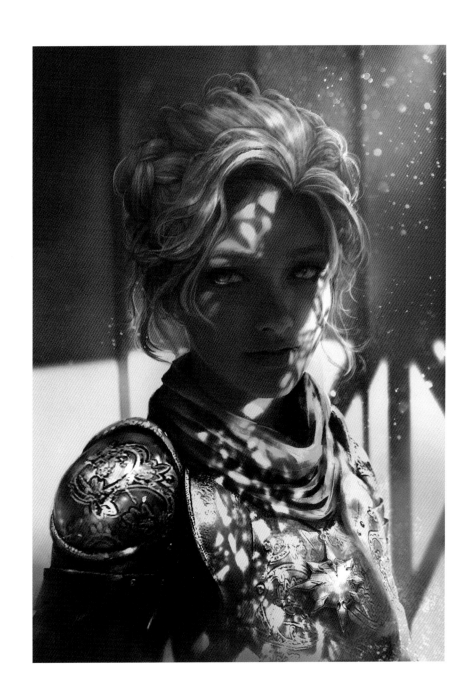

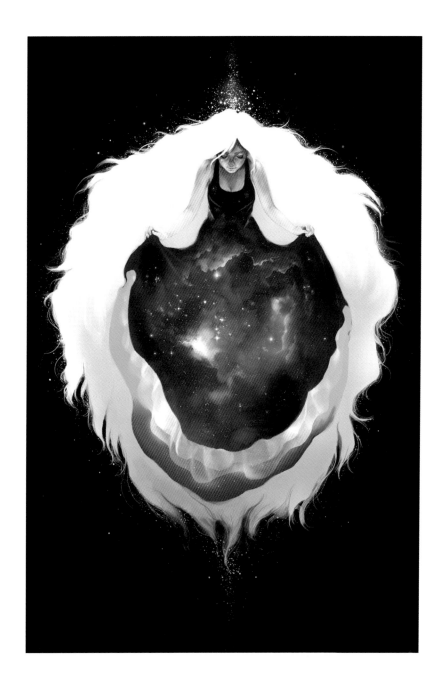

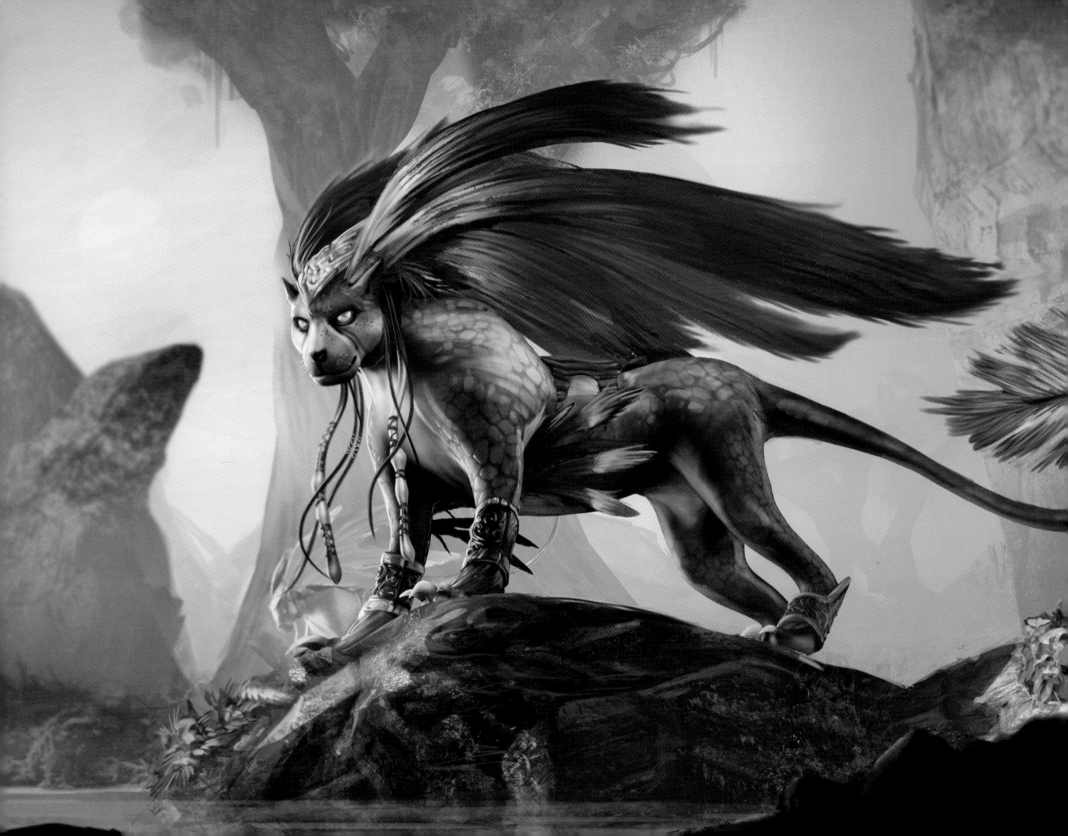

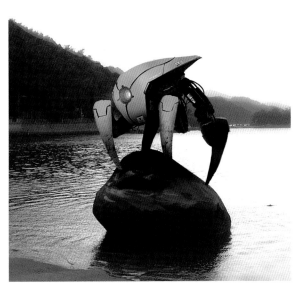

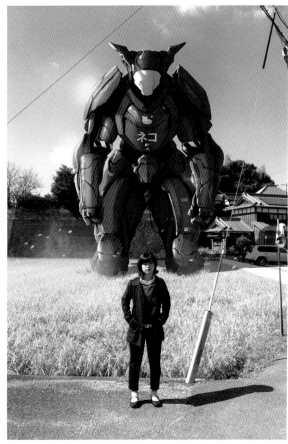

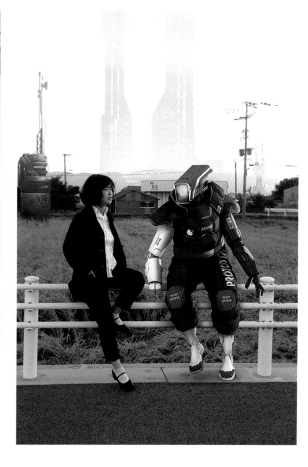

BRANDON FERNANDES

I'm Brandon, a concept artist/ illustrator living and working in Dubai. I've been a huge fan of video games, 3D animation and anime, particularly Studio Ghibli films, for as long as I can remember, and I've grown up surrounded by various forms of art. It was inevitable that I would pick up a pencil and just scribble away at any surface I could find. I worked hard at honing my skills, graduating with an Interactive Animation degree and undergoing a year of training under renowned digital artist Artgerm and the famous Imaginary Friends Studio team in Singapore.

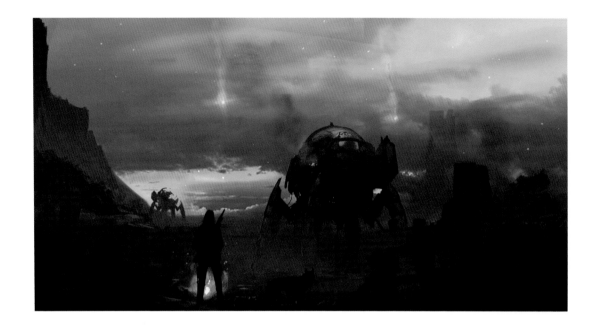

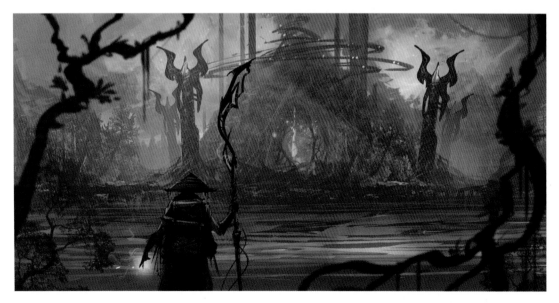

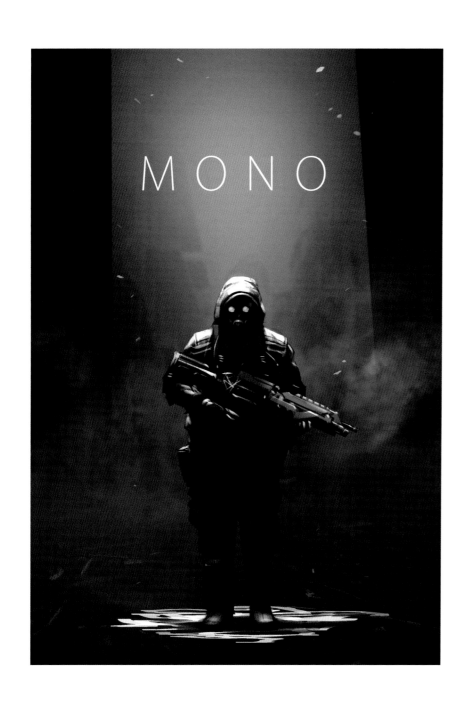

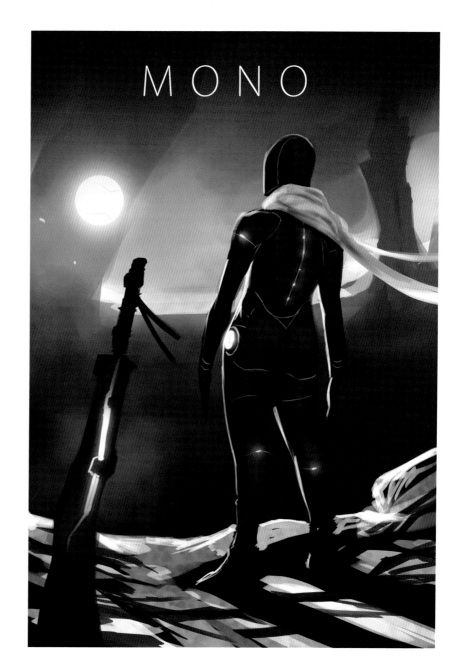

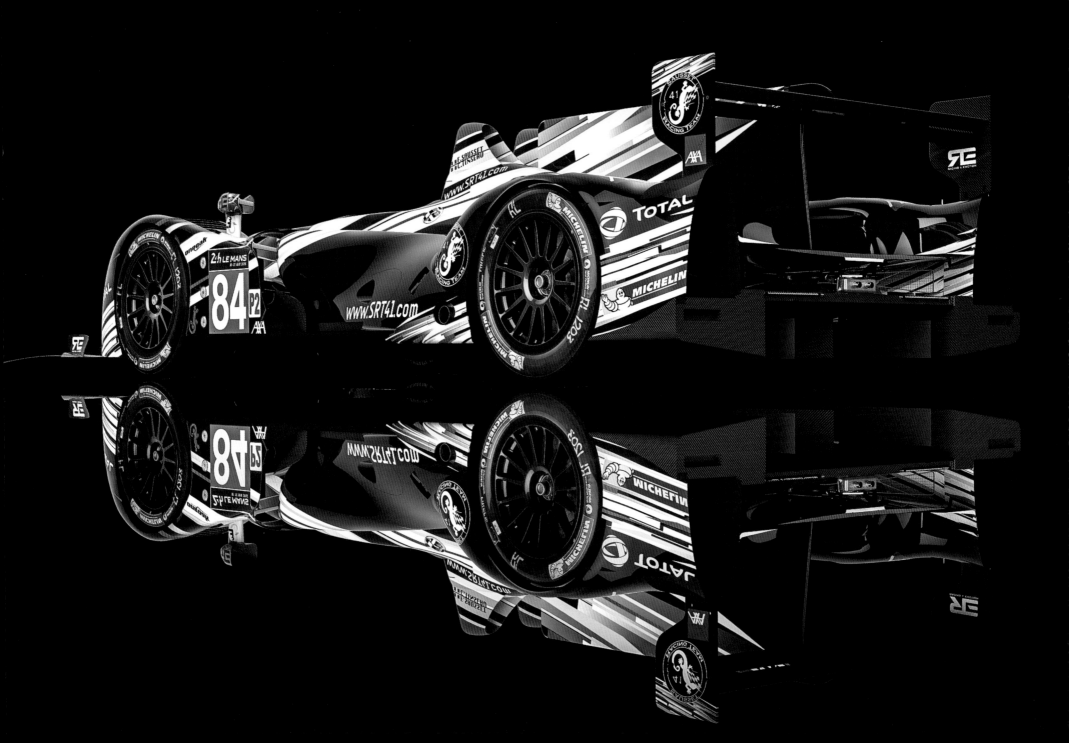

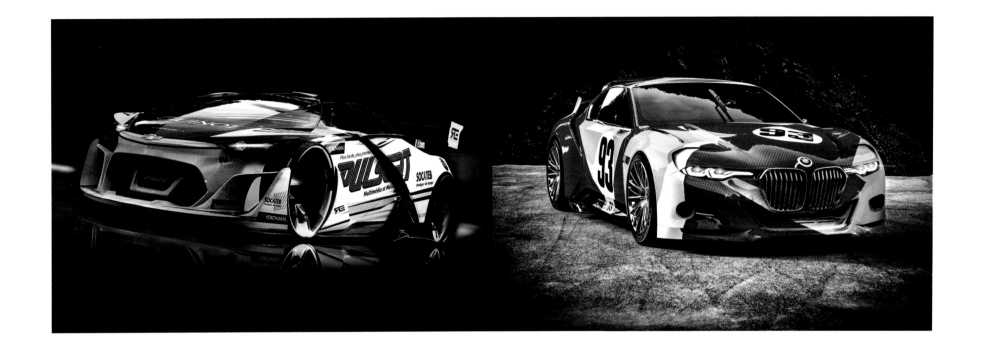

BENOIT FRAYLON

Raised in Le Mans, refined in the UK, currently under development in the UAE. With my solid background as an art director in the Classic & Sports Car magazine and the co-founder and brand ambassador of Racing & Emotion, my great passion for bringing concept art to life has enabled me to become the head of graphics & visuals at W Motors, the first Arabian manufacturer of hypercars in the Middle East. I am also a racer who suffers from what I like to call "a chronic addiction for speed".

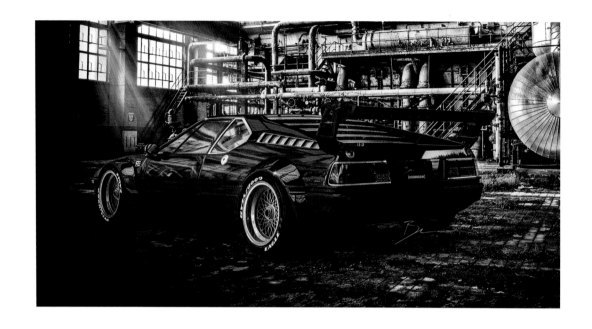

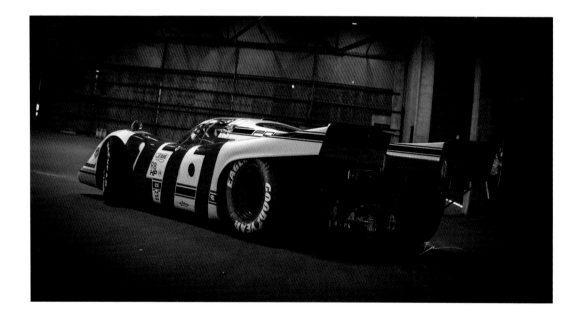

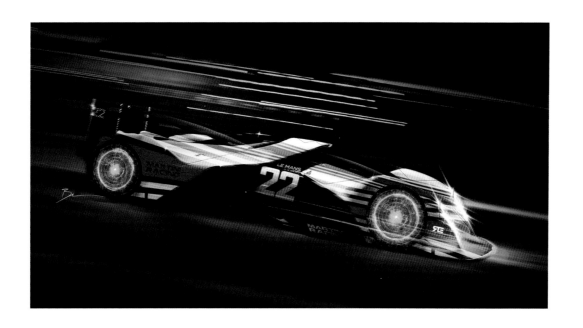

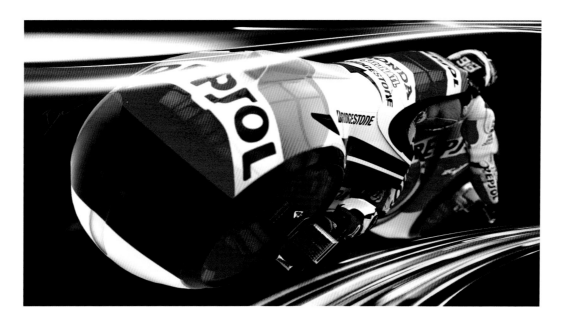

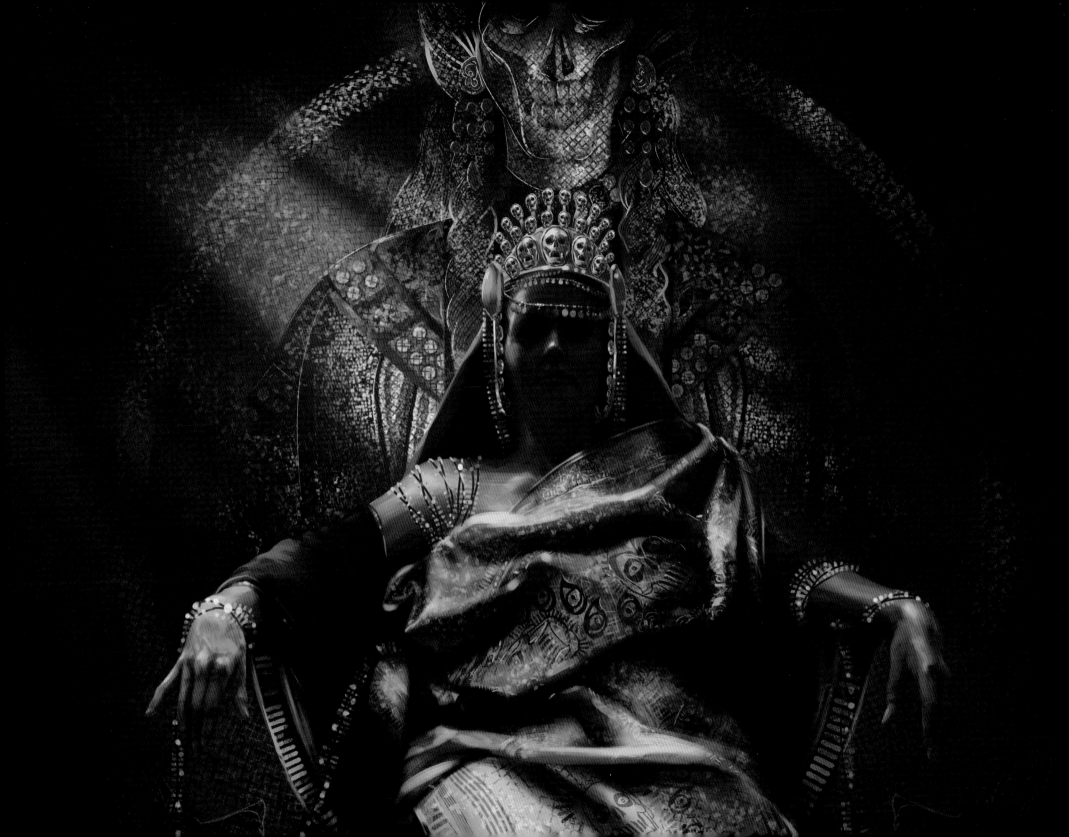

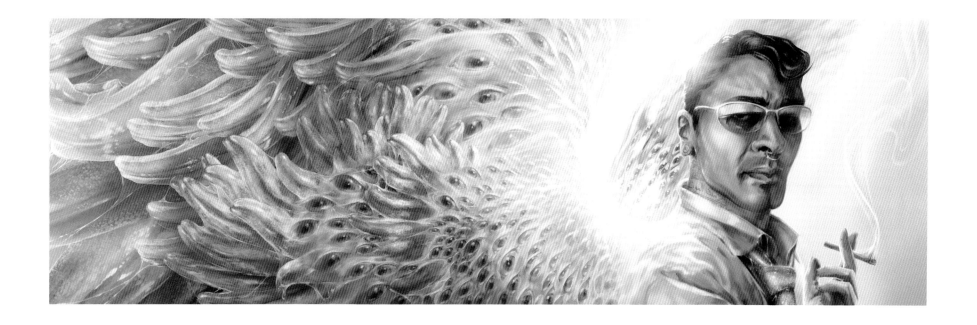

CASSANDRE BOLAN

I'm a fantasy illustrator specialized in women empowerment; I read voraciously about women's studies, goddesses, matriarchies, and anything pertaining to feminism in popular culture today... all while bouncing curly-headed babies on my knee! My achievements include a winner's title in the 2014 International Writers and Illustrators of the Future Contest, a feature in ImagineFX Magazine, and collaborations with prominent clients such as Fantasy Flight Games and Cartoon Network. My dream job? One that would allow me to bring varied female characters to life and ditch sexist tropes in favour of diversity, aptitude, and badassitude!

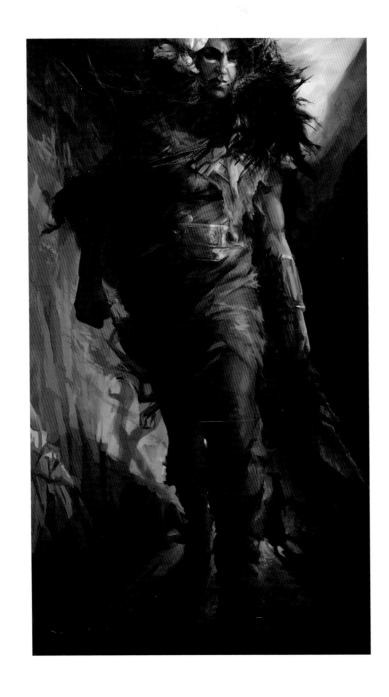
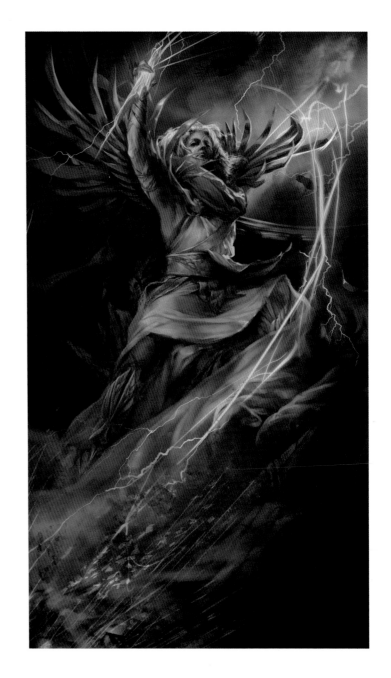

© CASSANDRE BOLAN

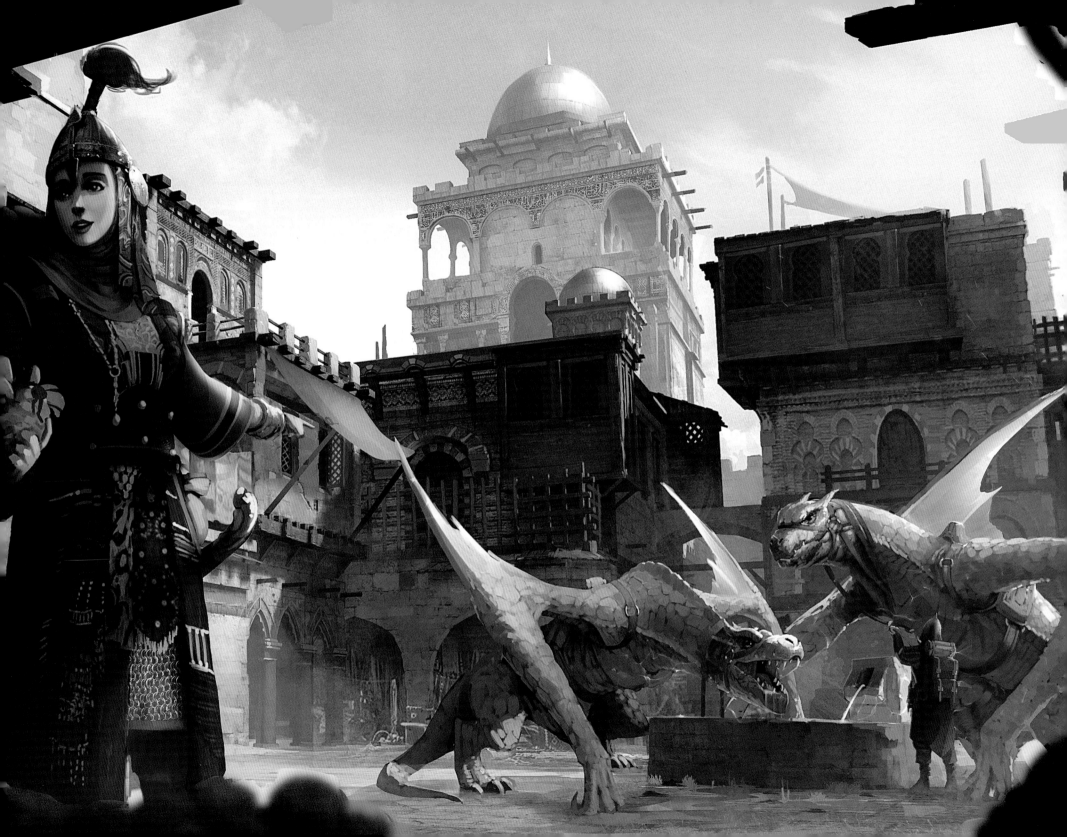

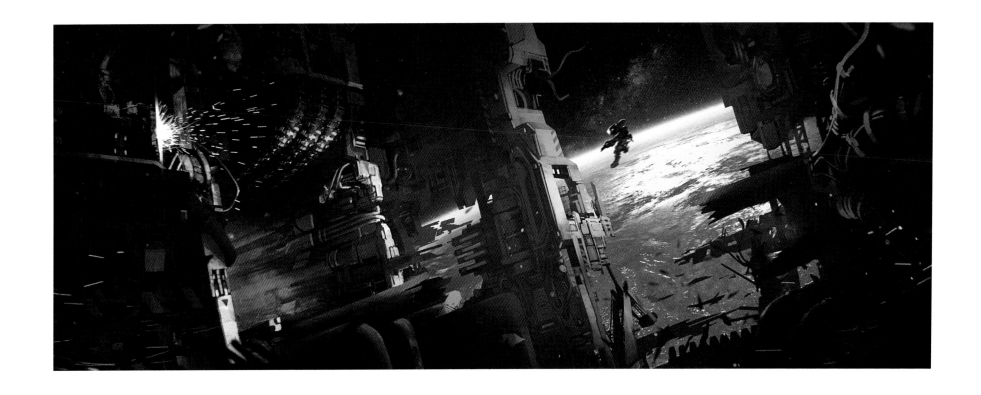

DANIEL MALLADA RODRIGUEZ

I'm an illustrator from Spain with a passion for books, video games and cinema, currently working as a concept artist on a mission to create vibrant environments and colour scripts, while paying careful attention to colour, lighting and fine rendering in all my pieces. I absolutely love everything fantasy and sci-fi, especially H. P. Lovecraft's narrative.

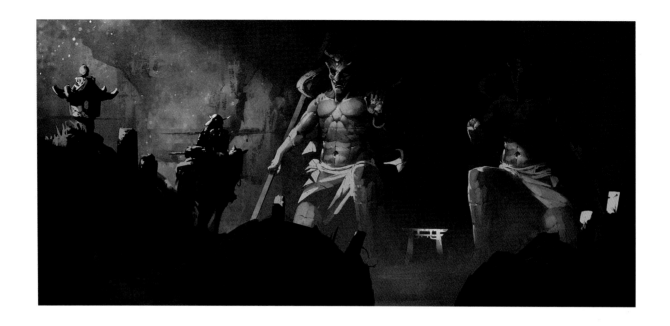

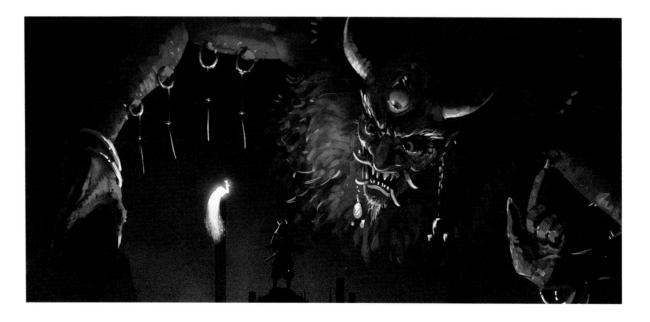

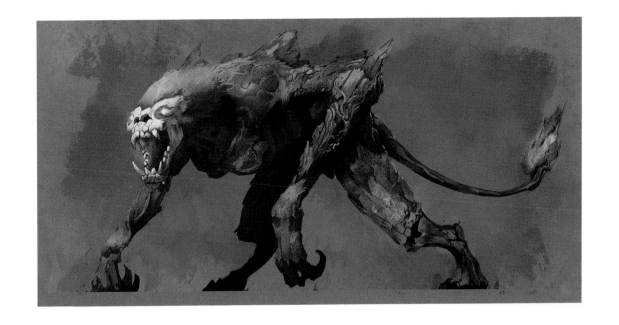

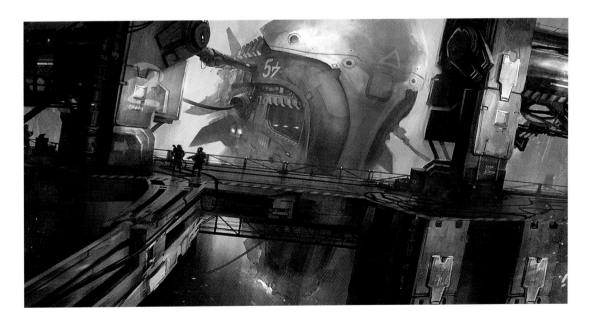

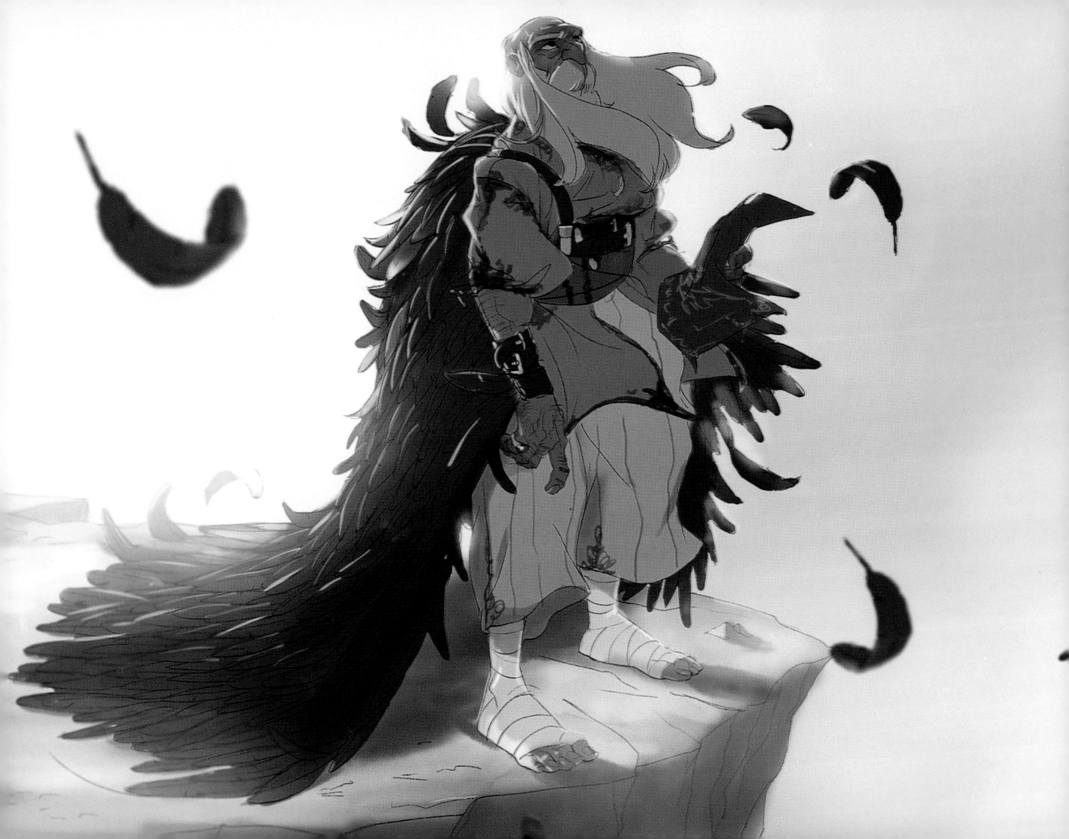

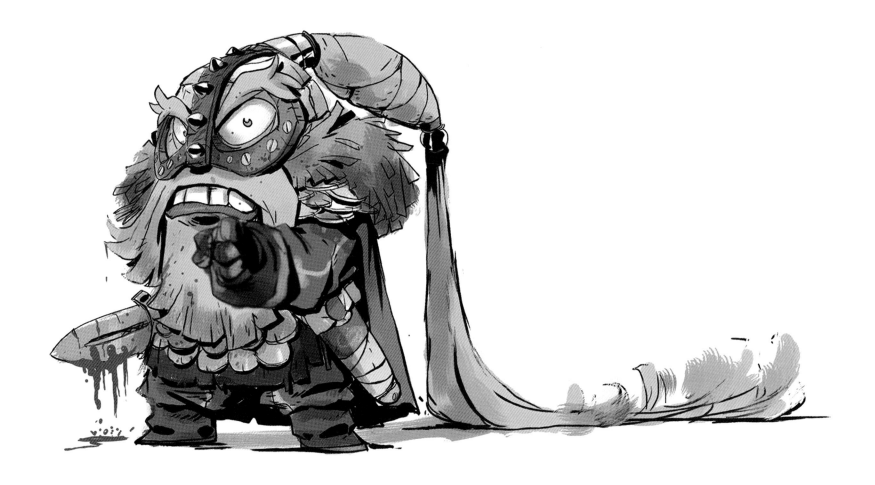

ESLAM ABOSHADY

Though I studied Law at university, it is what I taught myself that has turned into my career - character design and comic art. In 2010, I began working as a professional artist, starting small at first as a freelancer, before joining several studios. I dabbled in animation, games and advertising, and I am currently a concept artist at Aroma Productions in Egypt.

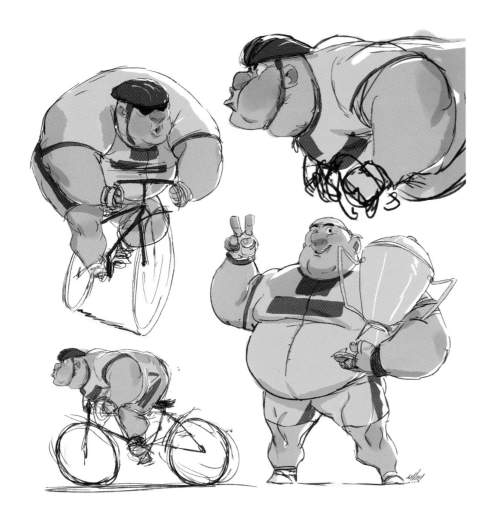

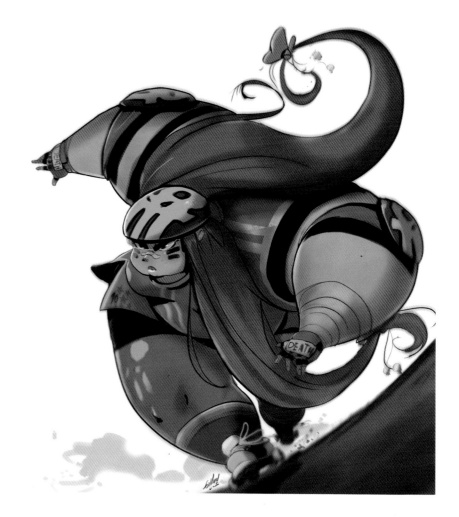

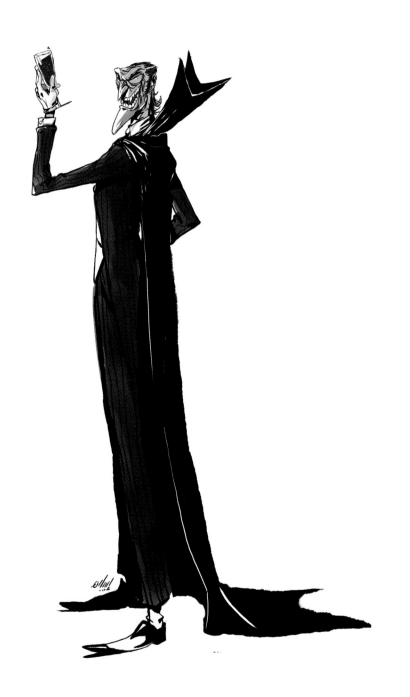
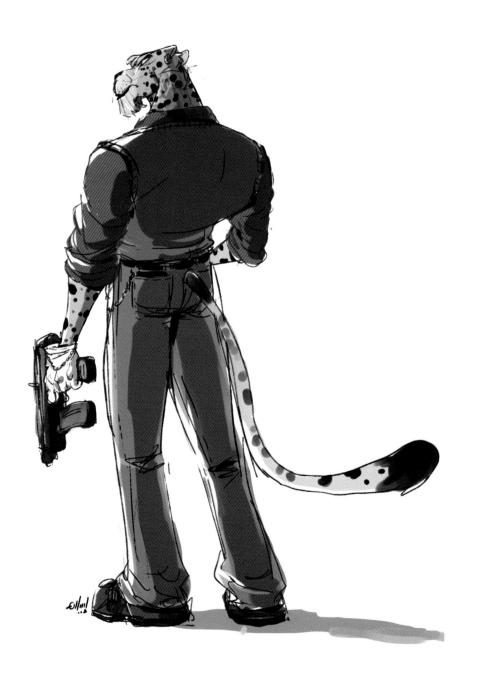

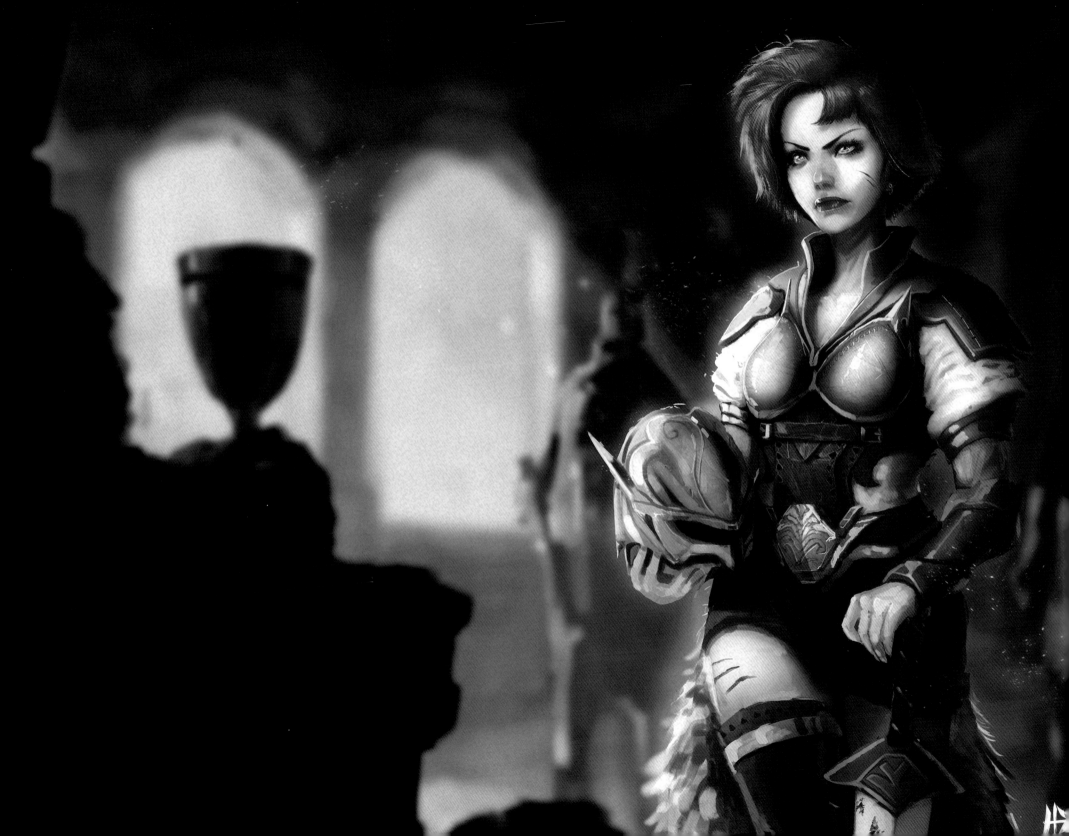

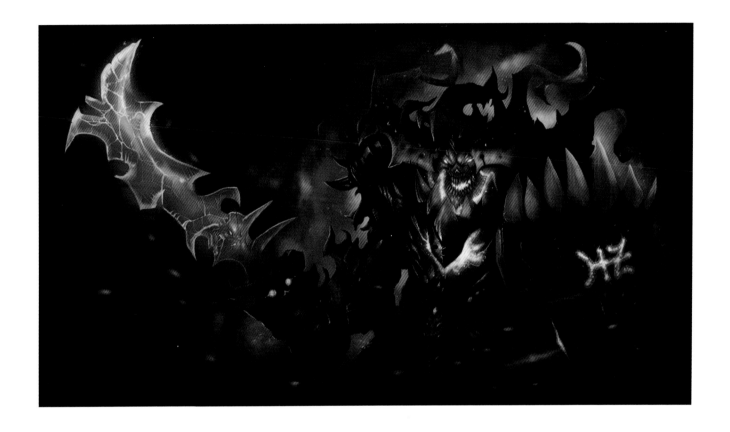

HICHEM ZARRAD

I have always been in love with all kinds of art - drawing, music composition, animation - and through my work in several game design studios, I had the opportunity to experiment in all these different domains. I'm always striving to become a better artist, which I know can only be achieved through careful observation, constant practice and a better grasp on the elements of my trade.

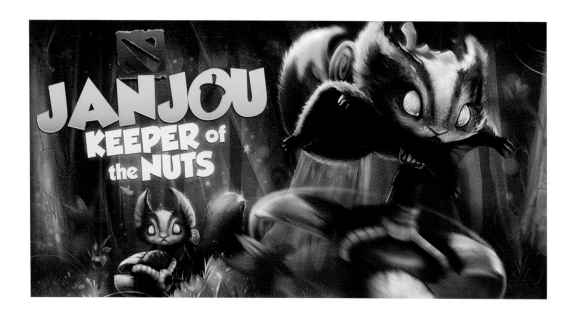

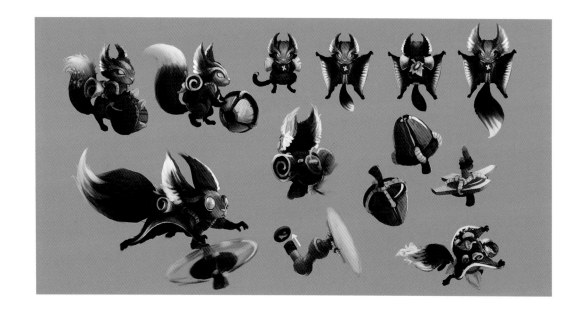

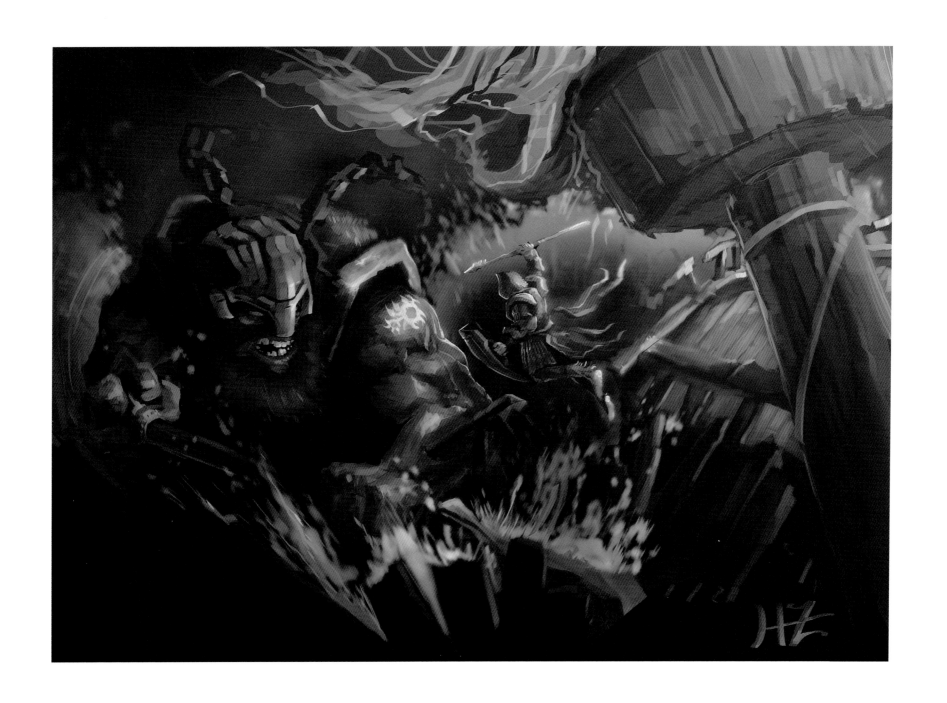

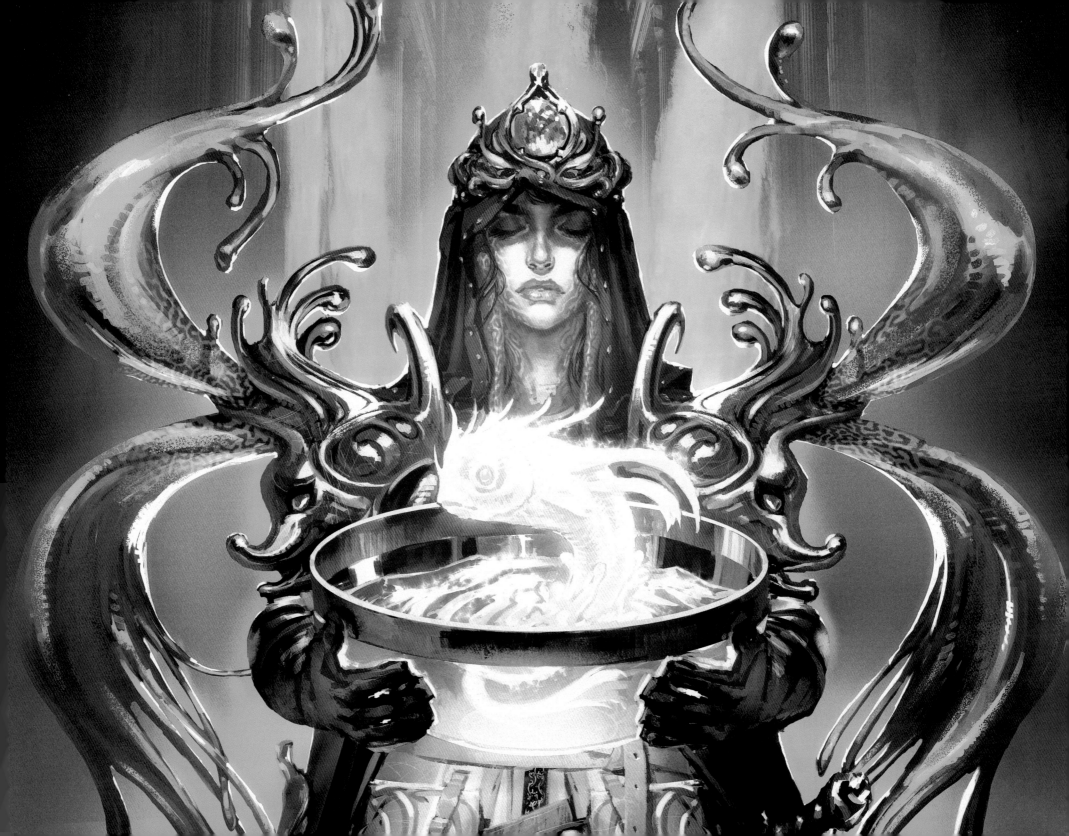

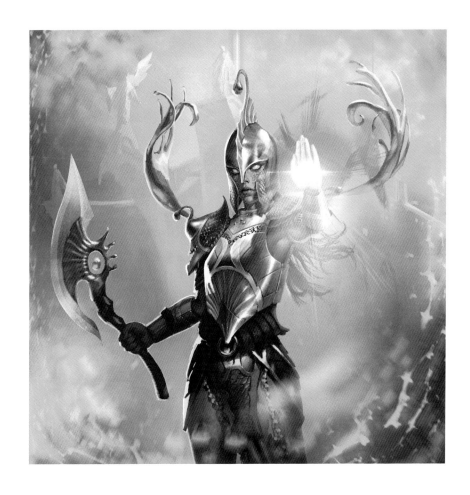

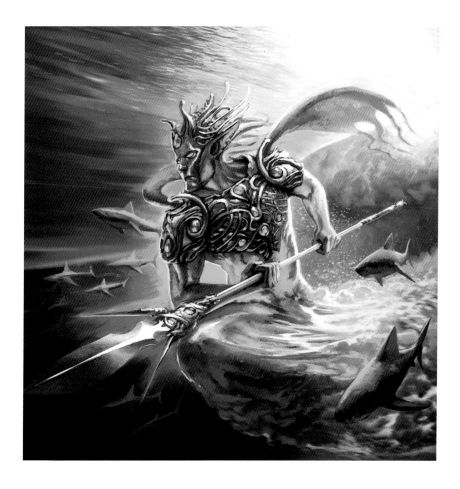

IBRAHEM SWAID

Born in 1985 in Damascus, Syria, I am a digital illustrator, a concept/ game designer and the co-founder of Nucleus Games, an indie dev studio based in Ras al-Khaimah, UAE, through which we recently produced a game called "Jump Rope". Though I graduated with a degree in fine arts in 2008, I find that there's no end to the learning process, and my love for illustration keeps me going. When I'm not working, I like to sink in a few hours playing strategy games and reasoning to myself why a new art book is crucial to my already sizeable collection.

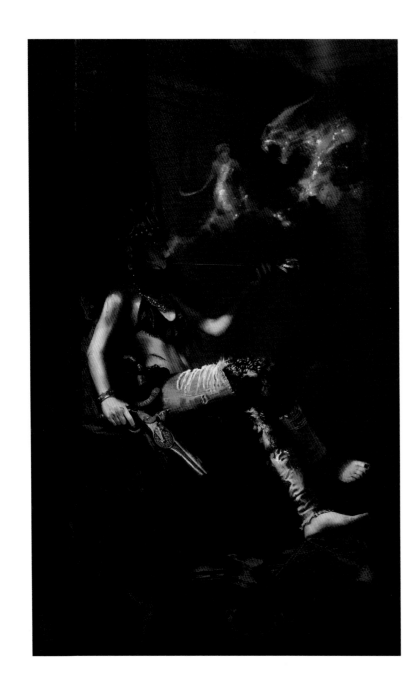

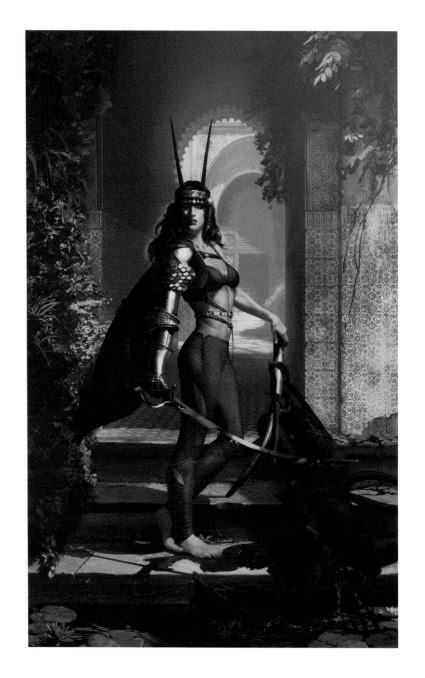

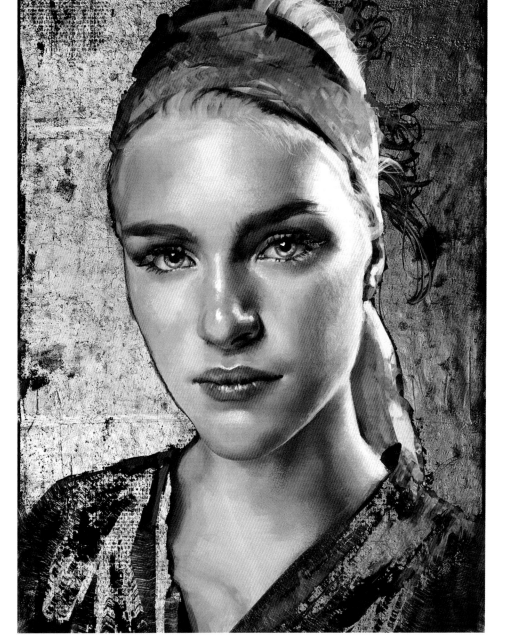

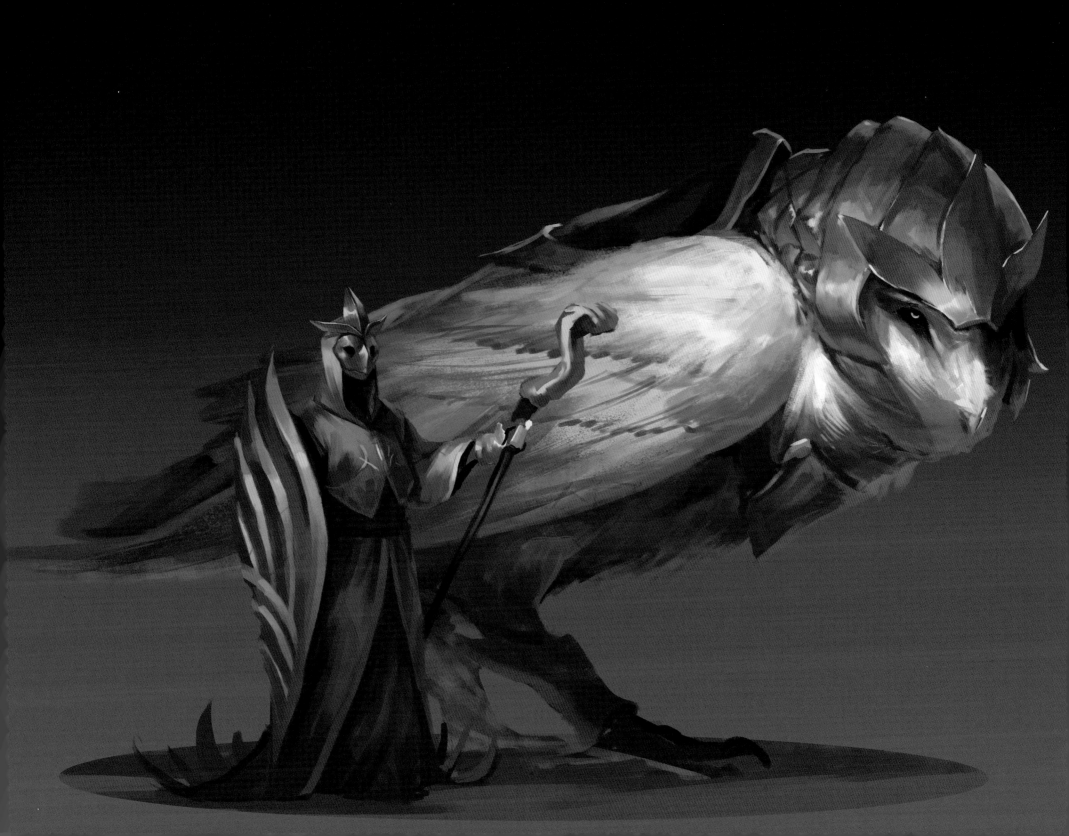

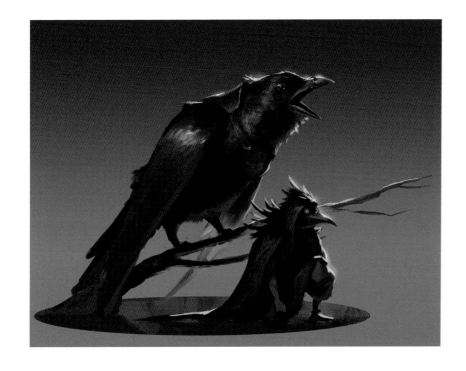

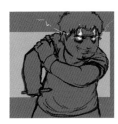

JOSHUA CORPUZ

I'm an artist currently residing in Abu Dhabi, and I've worked with several clients including Bethesda, Hasbro and Paizo. Apart from that, I like to think I'm your normal everyday guy, but apparently normal guys leave their houses during weekends, not spend them binge watching anime, playing games or painting.

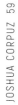

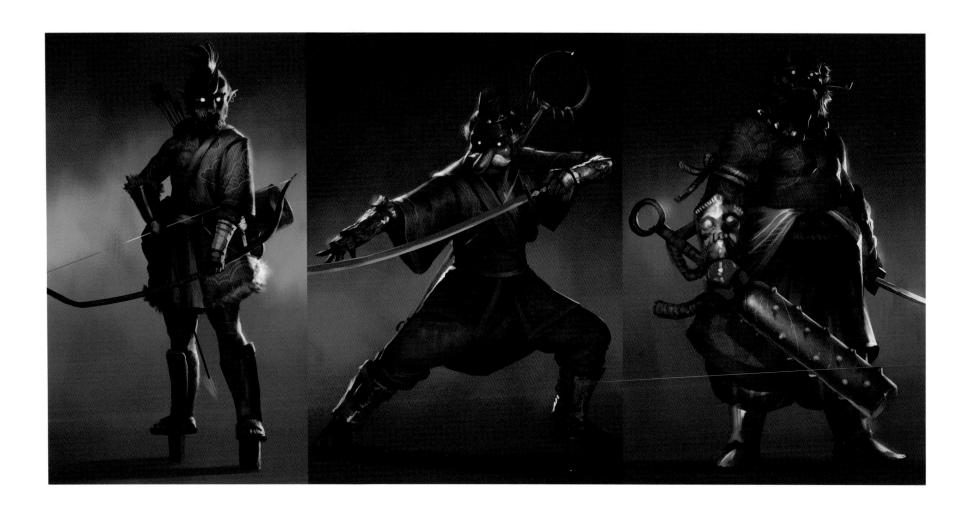

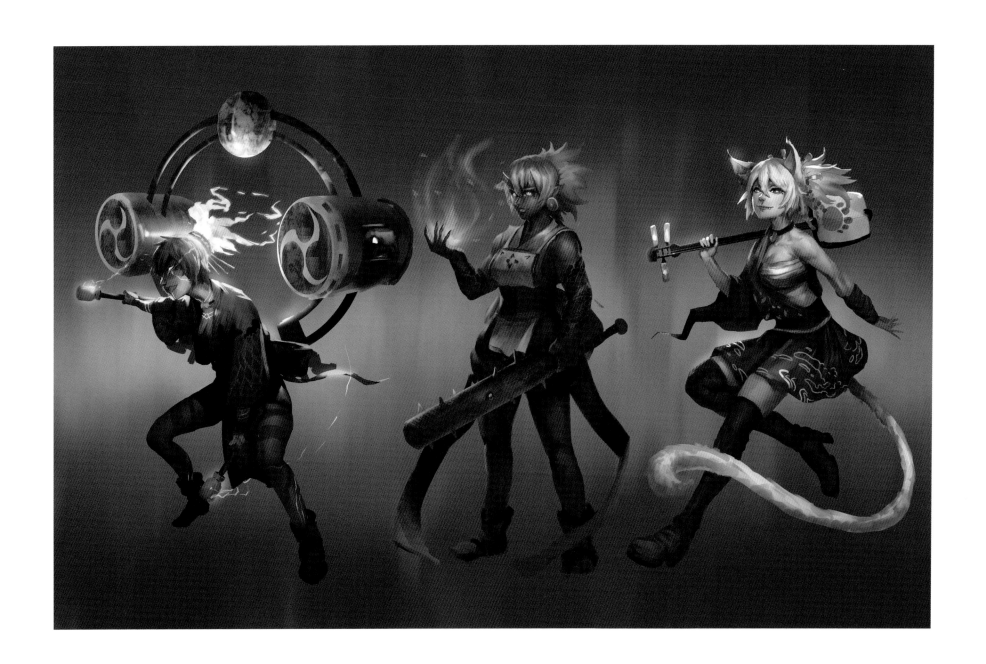

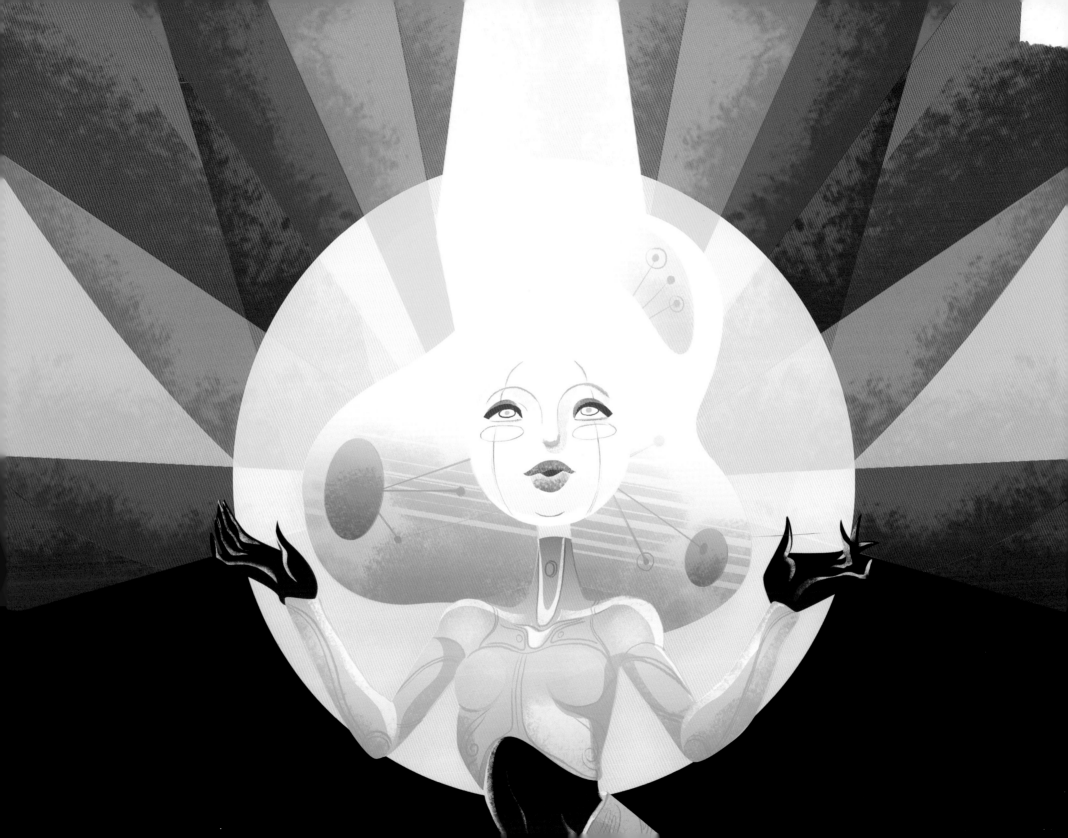

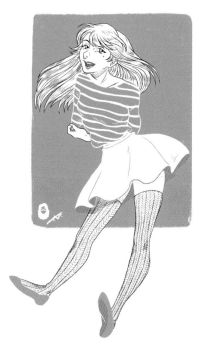

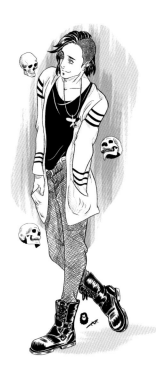

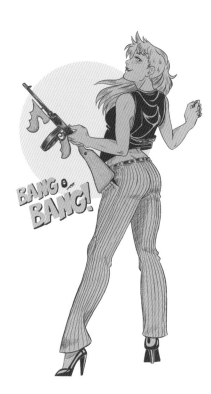

JOUMANA ISMAIL

I am an illustrator and character designer from Syria currently living in Dubai, UAE. I'm a day dreamer, and I enjoy observing coffee shop frequenters and having endless conversations with my characters – a perfectly normal activity for artists, I would like to assure you! People and nature are my biggest sources of inspiration, and I'm also a bit old-school in the sense that I love ink, with all its finger stains and messiness… I'm just fascinated by how each brush stroke leaves a unique imprint on paper – much like a snowflake, no two strokes are alike.

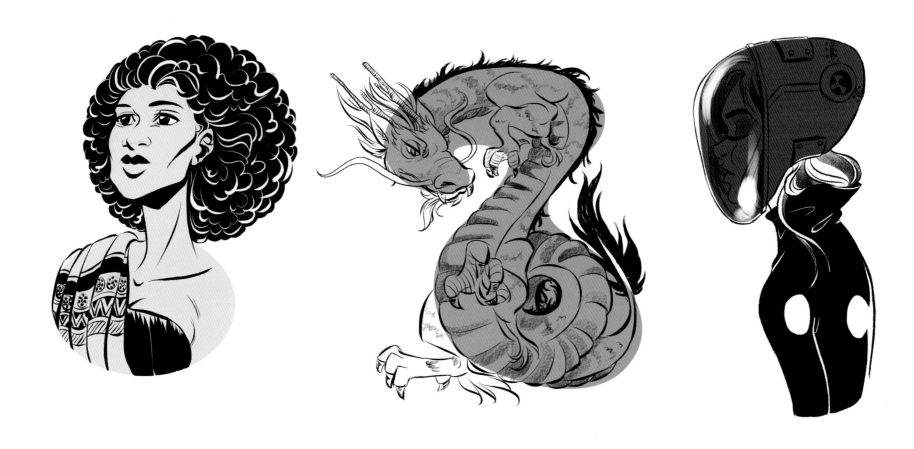

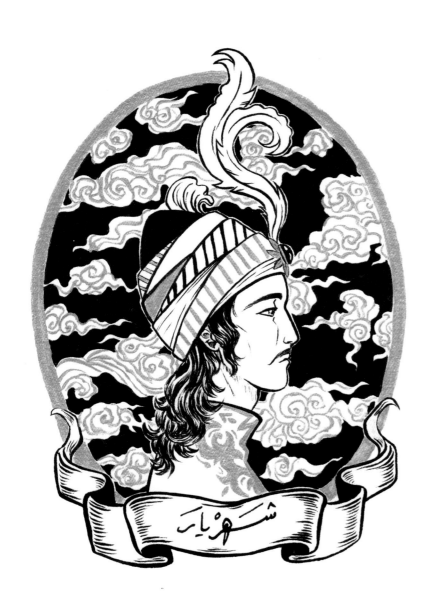

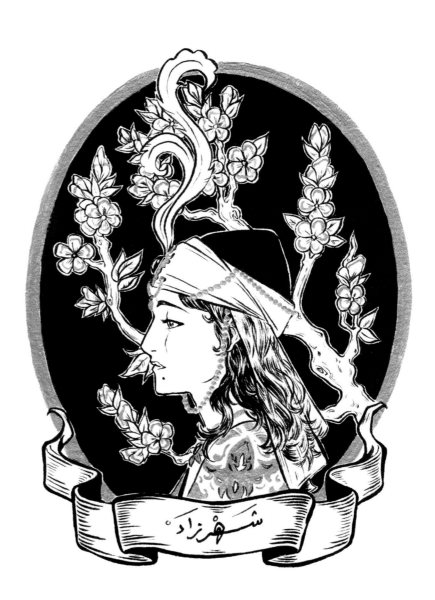

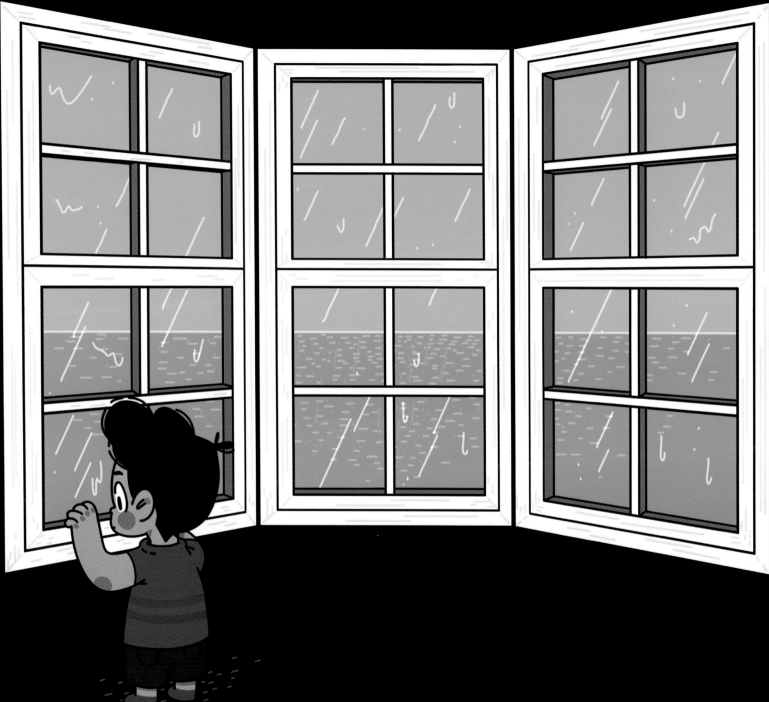

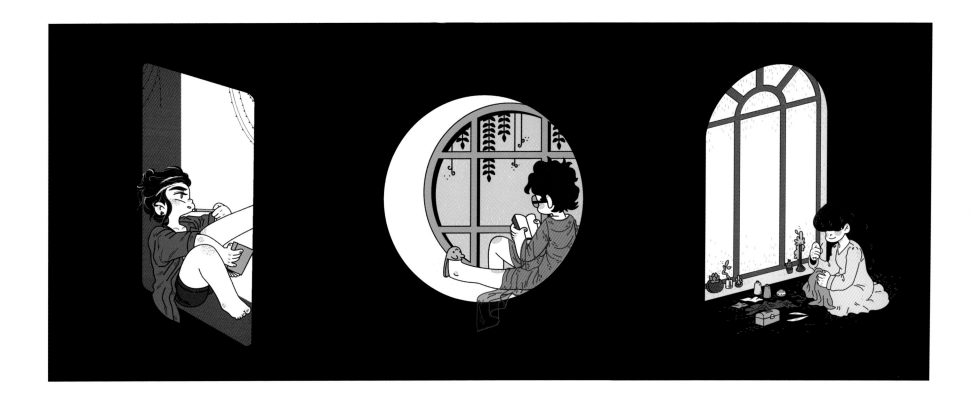

KHADIJA AL SAEEDI

Originally from Oman, I moved to Abu Dhabi (UAE) where I graduated from the Cartoon Network Animation Academy and worked as an animation artist at Cartoon Network Studios Arabia for 4 years. I'm currently freelancing in different fields including 2D animation, indie video games, comics, character design and story development. I like to think I'm also a bit of a social media guru – I mean, I run all sorts of art events and interactive projects such as the Artists Working podcast, so that should count for something, right?

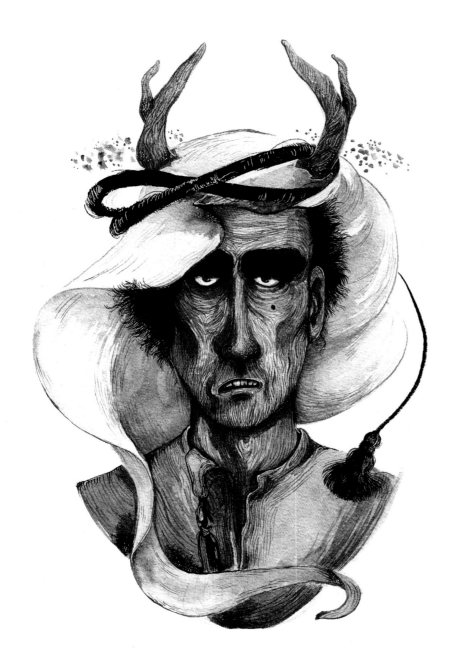

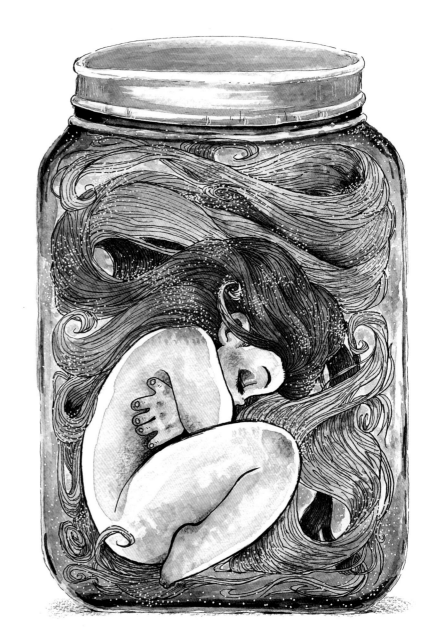

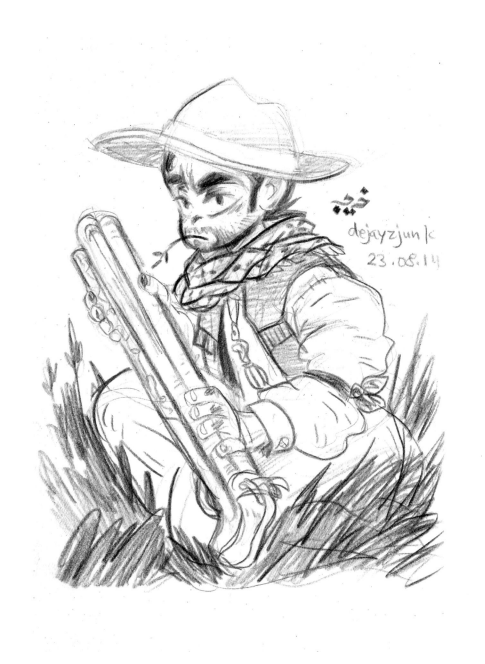

dejayzjun lc
23.05.14

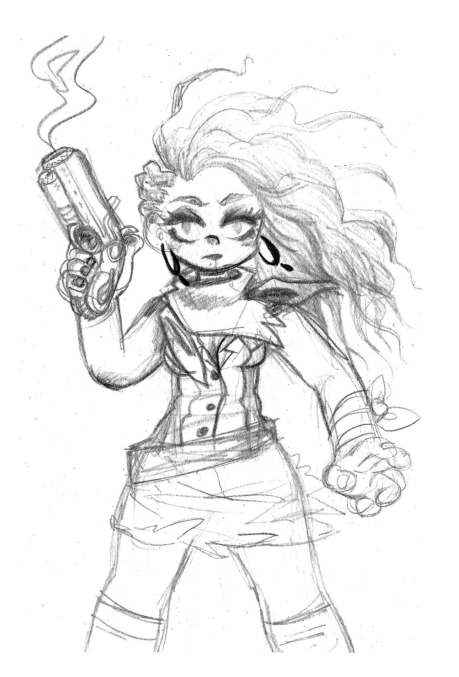

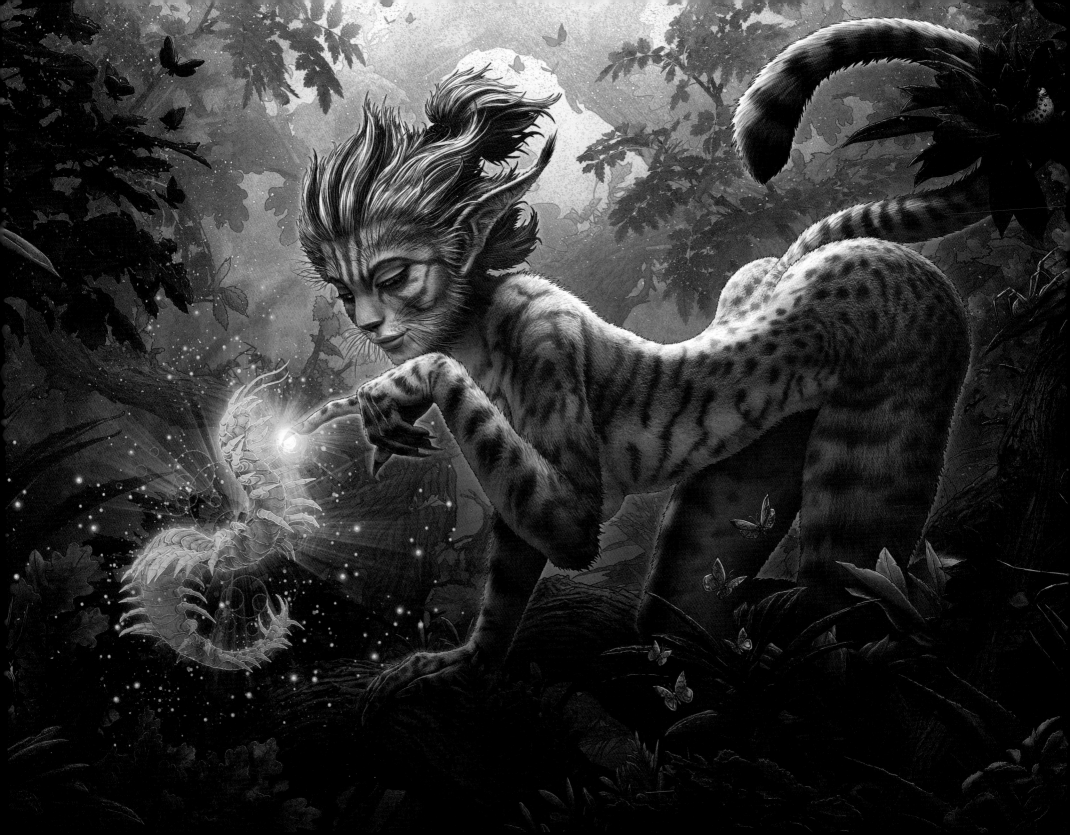

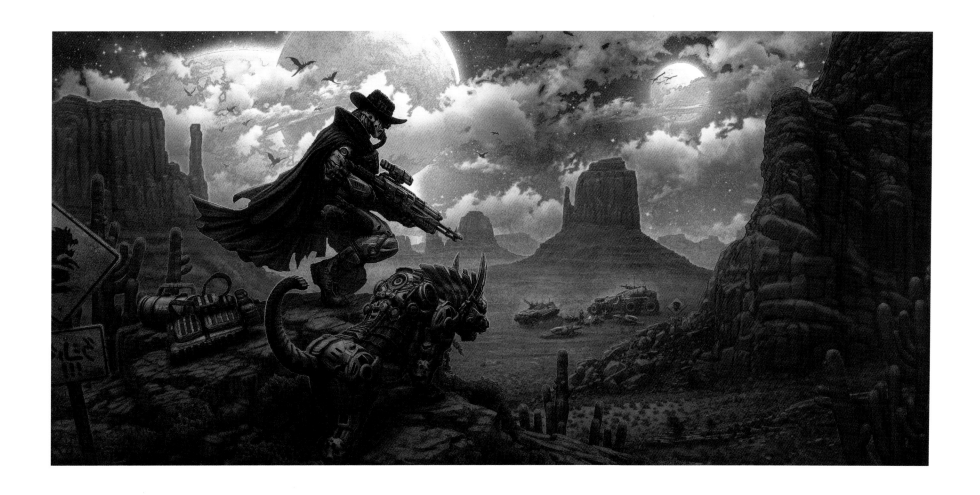

KEREM BEYIT

Drawing has been a passion of mine for as long as I could remember, though it took me a while to take it up professionally given the stigma associated with it in my homeland – "drawing cannot earn you bread money," is what they'll tell you. As of 2004, however, I have become a disciplined freelancing artist, and the bulk of my work has so far comprised book covers, character designs and fantasy-themed artworks, as well as illustrations for the Star Wars Galaxies trading card game. I'm also an avid comic reader, gamer, movie buff and 1/6 scale collector.

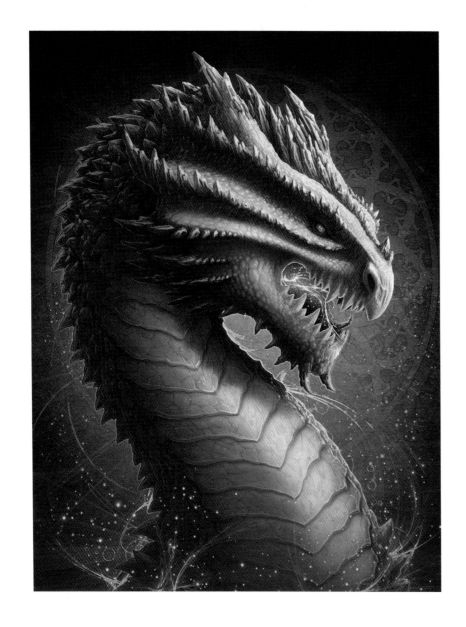

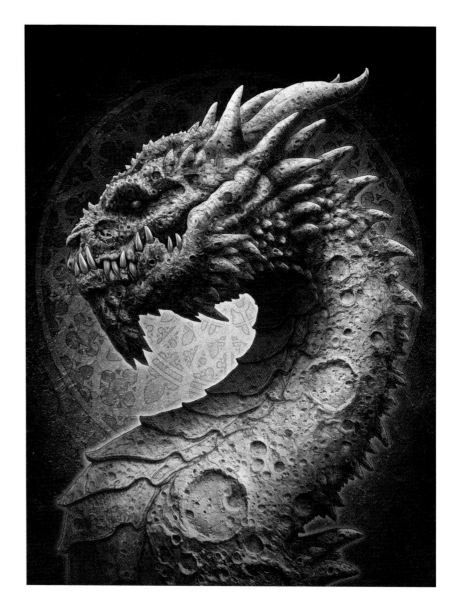

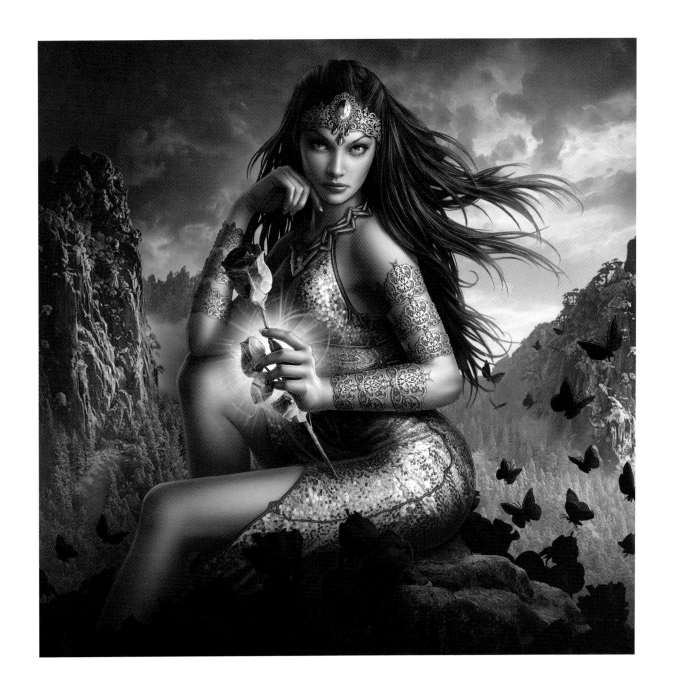

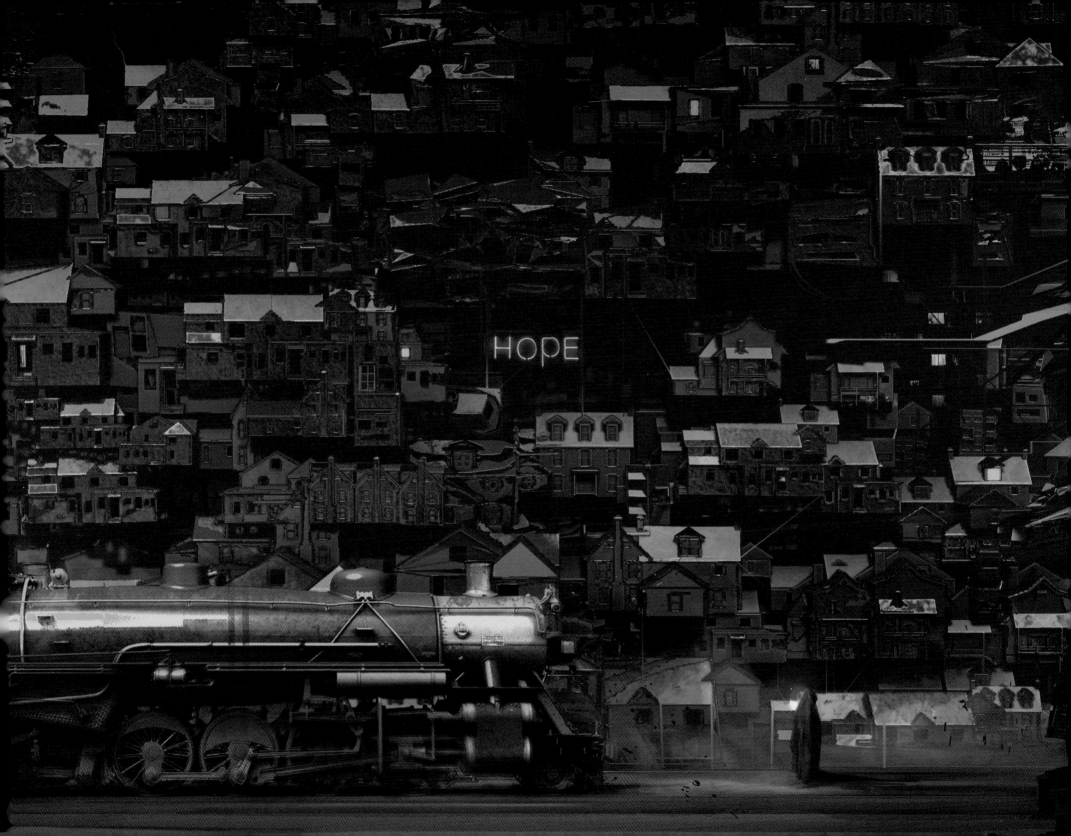

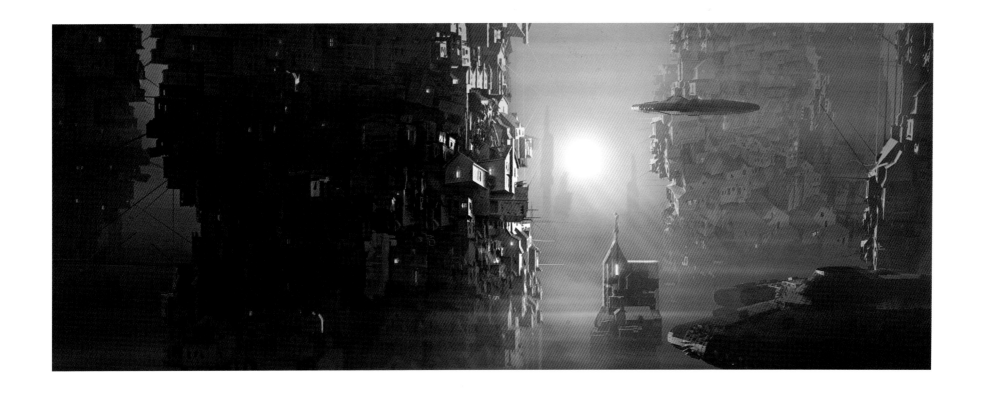

MOHAMED AL SADANY

Born in Alexandria, Egypt, I've been working in the CG industry for over 10 years. I'm a 3D generalist and concept artist with a focus on digital sculpting, lighting and compositing, and the tools of my trade are ZBrush, 3ds Max, Mari, Photoshop and Adobe After Effects. I also founded my own studio, the Animation House, in 2012.

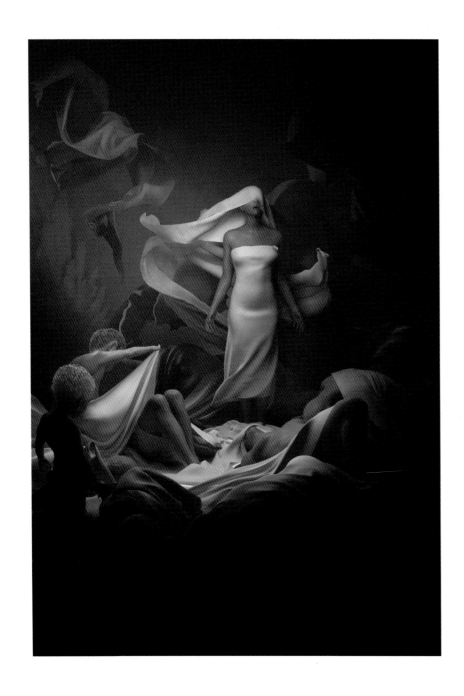

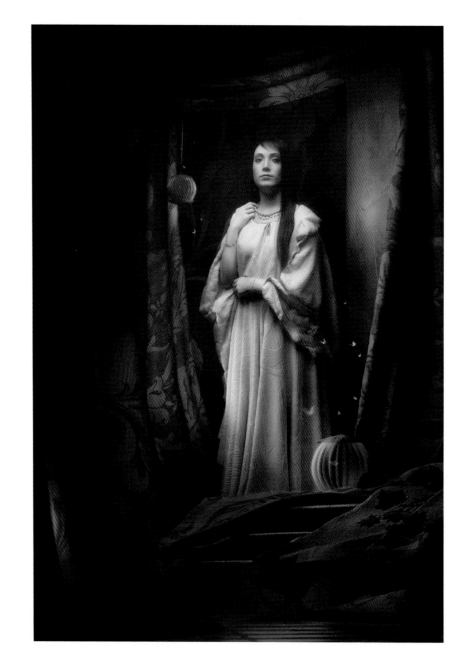

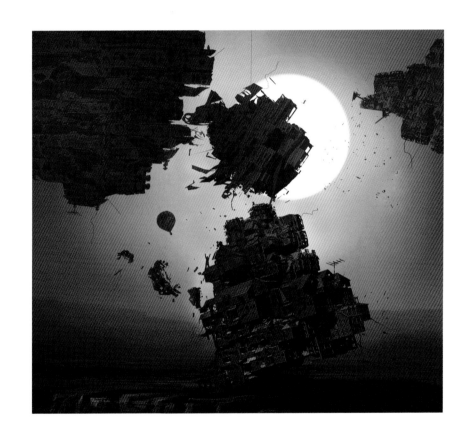

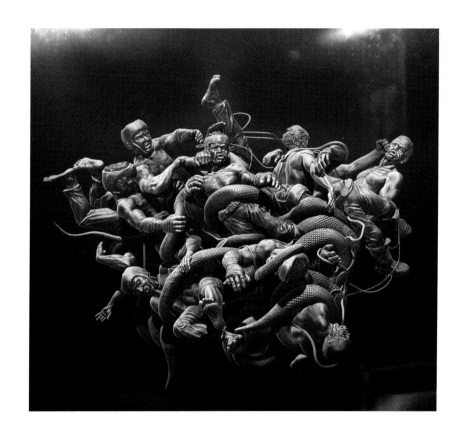

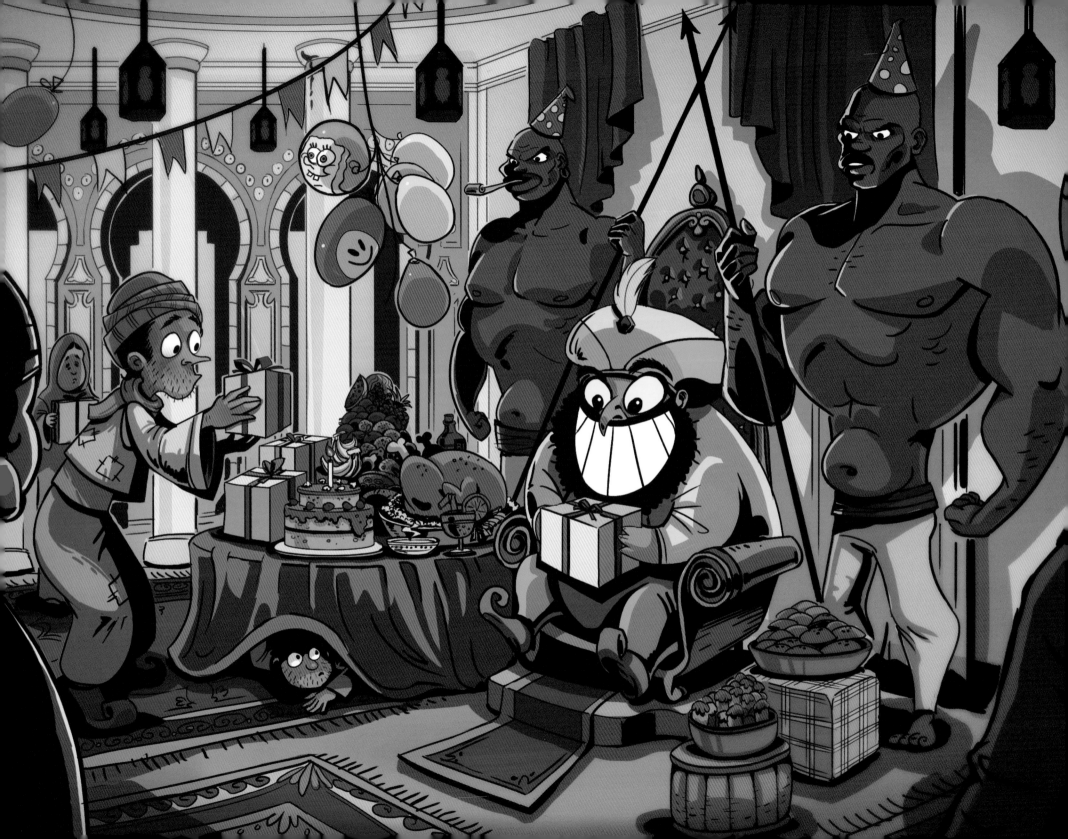

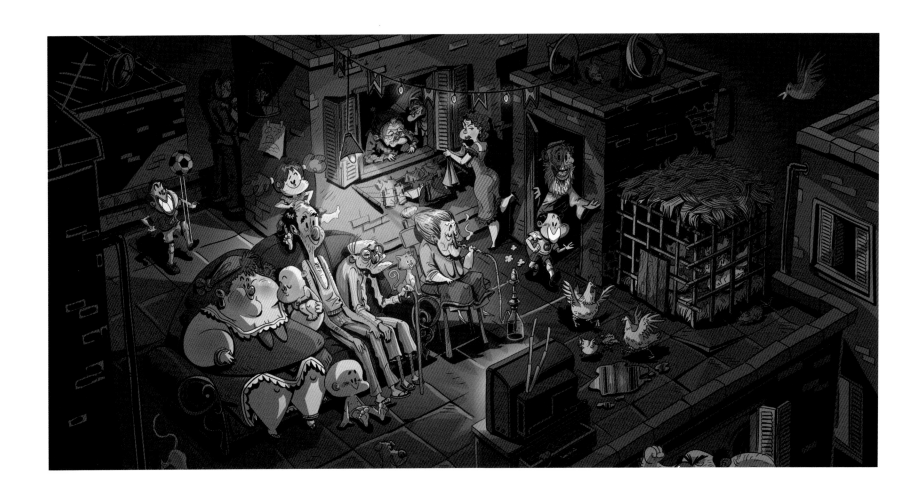

MOHAMED ALI

I'm an Egyptian artist with a love for travelling that has recently brought me to Dubai, where I now work as an art director and a freelance cartoonist. My illustrations and comics have been featured in popular children's magazines in the Arab world, such as Majid and TokTok. I'm also a bit of a bookworm... to the point where it's become normal for me to leave books and comics in my bathroom.

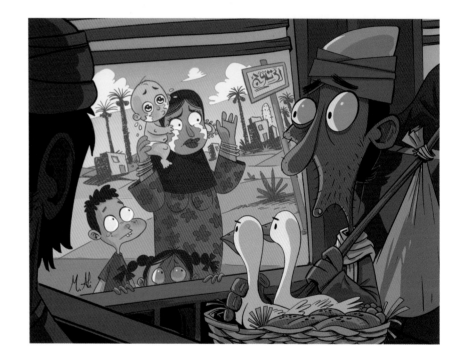

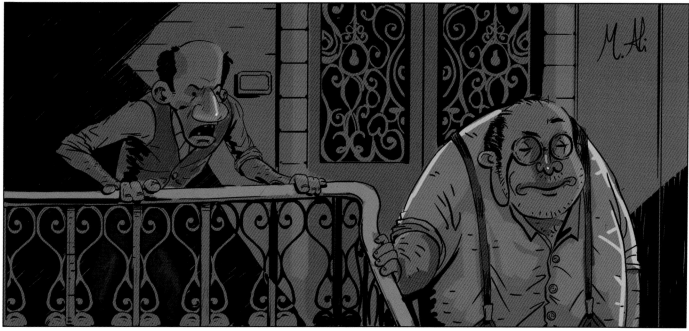

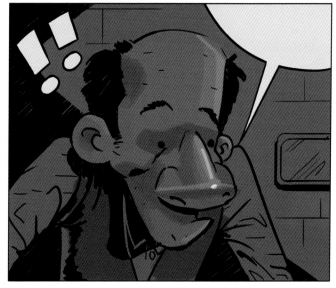

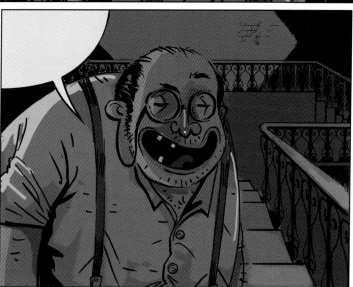

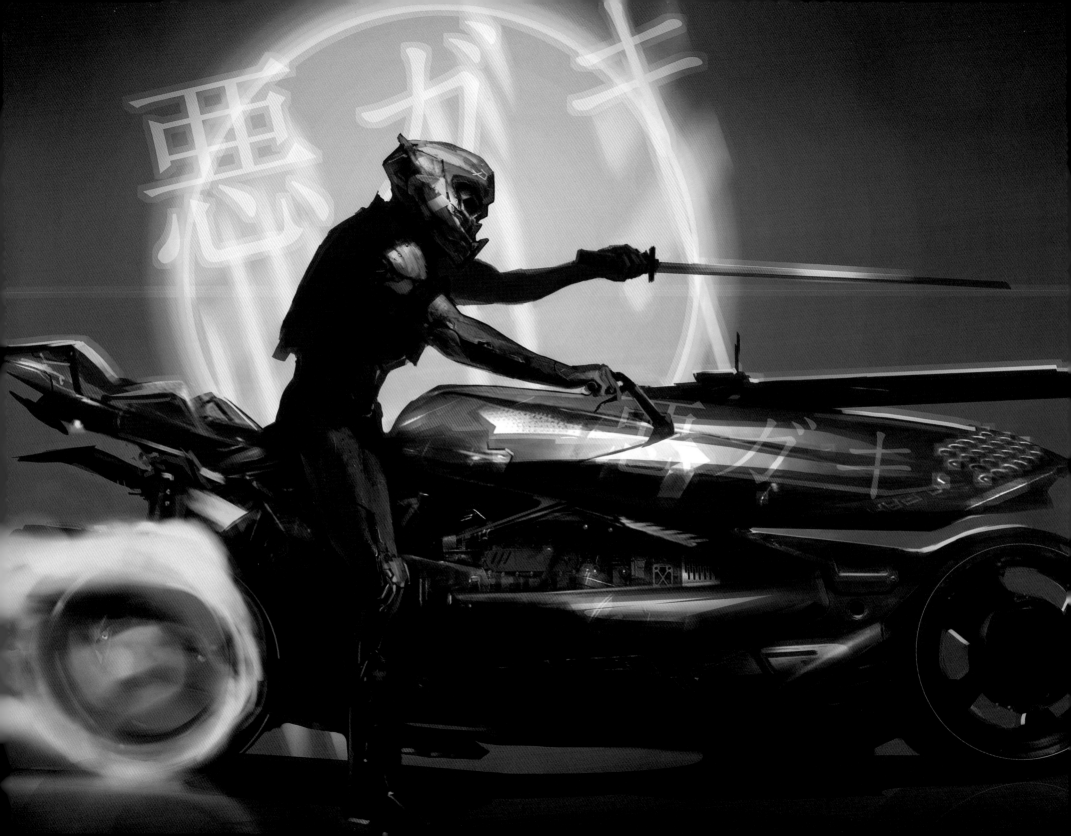

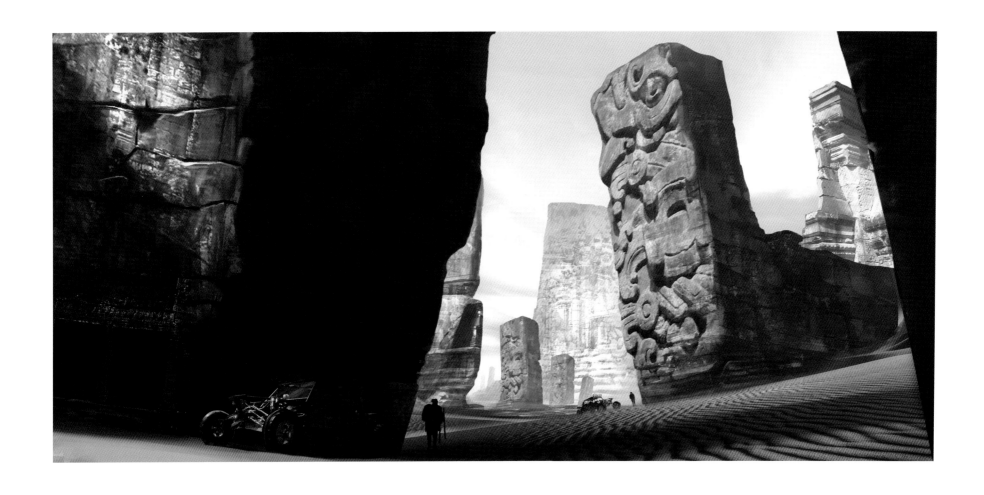

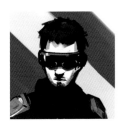

MUSTAFA LAMRANI

I am a concept artist working in the games and film industry. Robots, vehicles and environments are my forte, and I have worked on multiple projects with Ubisoft and other video games companies. I'm currently in Dubai, working for an animation studio where I get to spend my days doing what I love and painting cartoon elements.

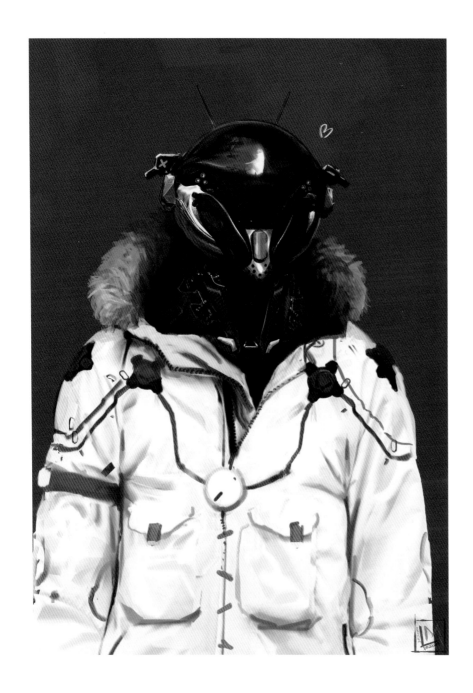

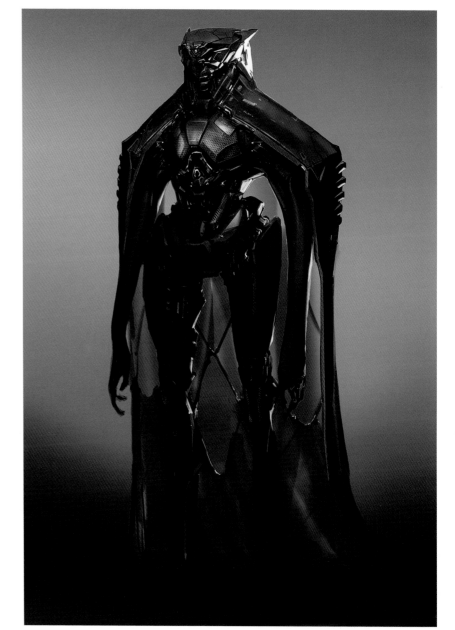

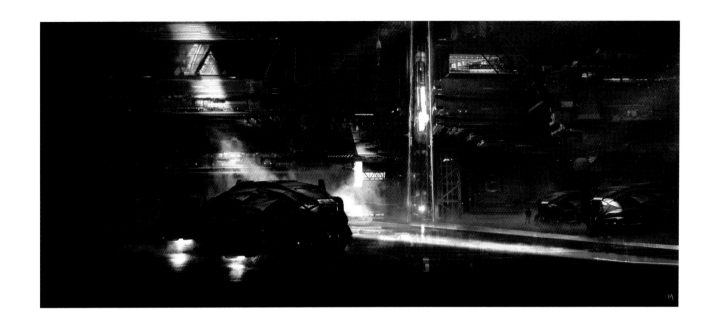

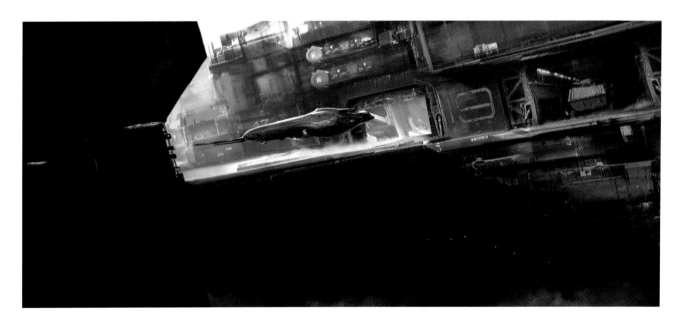

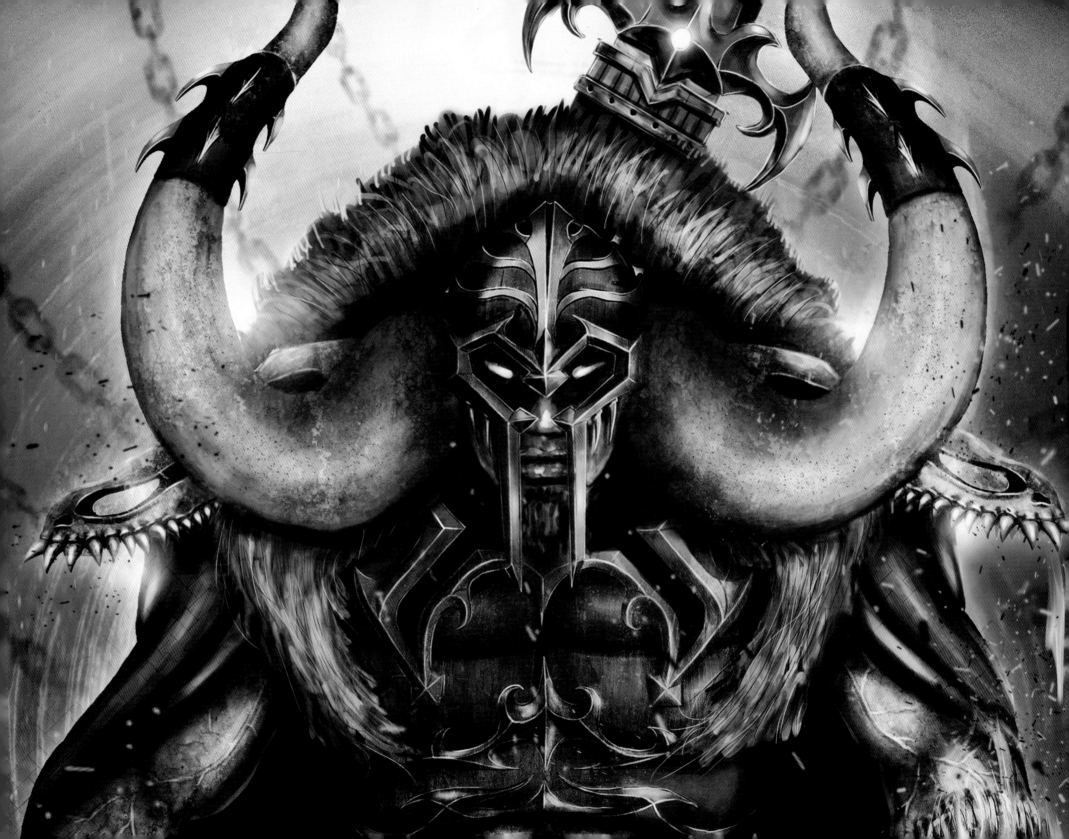

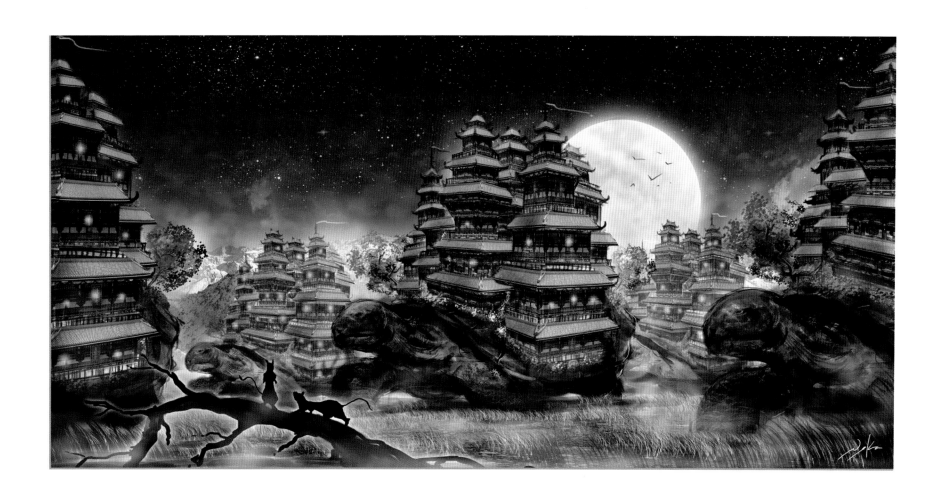

NAKA ISURITA

My career has taken me through the Philippines, where I graduated with a BA in Advertising and Commercial Art, relocated me to Dubai where I stayed for 8 years, and finally hauled me and my equipment all the way to cold ol' Canada. Across these three countries I've accumulated experience as a graphic designer, concept artist, illustrator and 3D artist in various fields such as advertising, marketing and industrial, architectural and entertainment design, and my style has varied between cartoonish and realistic.

Fun fact: I am a bit old school, in the sense that I always start on a piece with a traditional pencil before finalizing it on a computer.

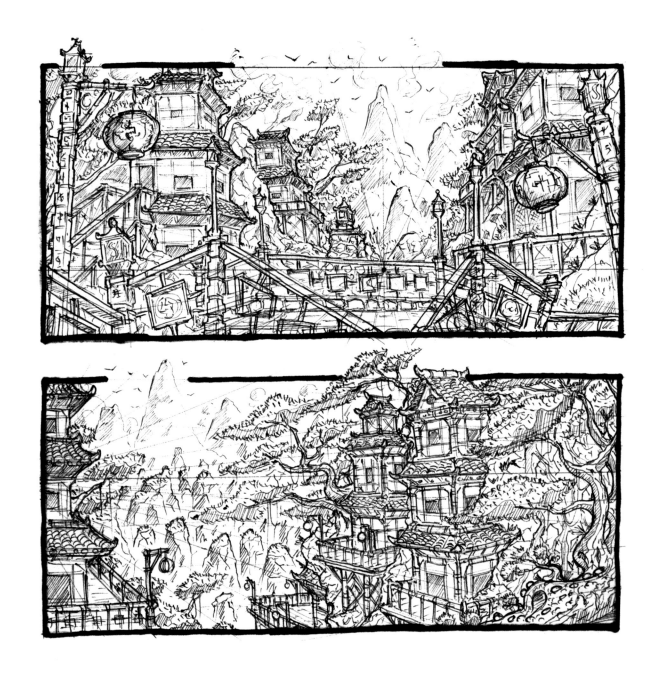

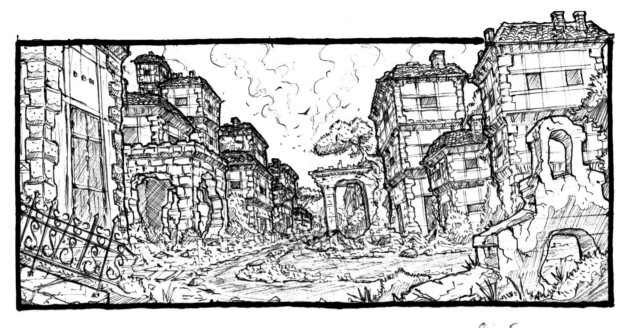

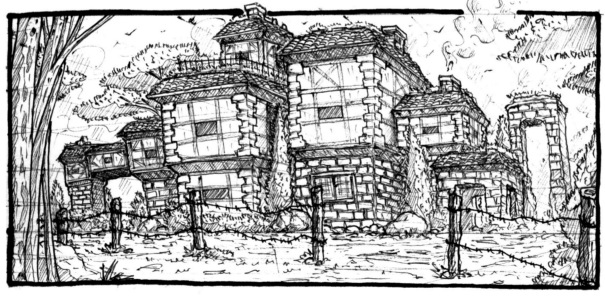

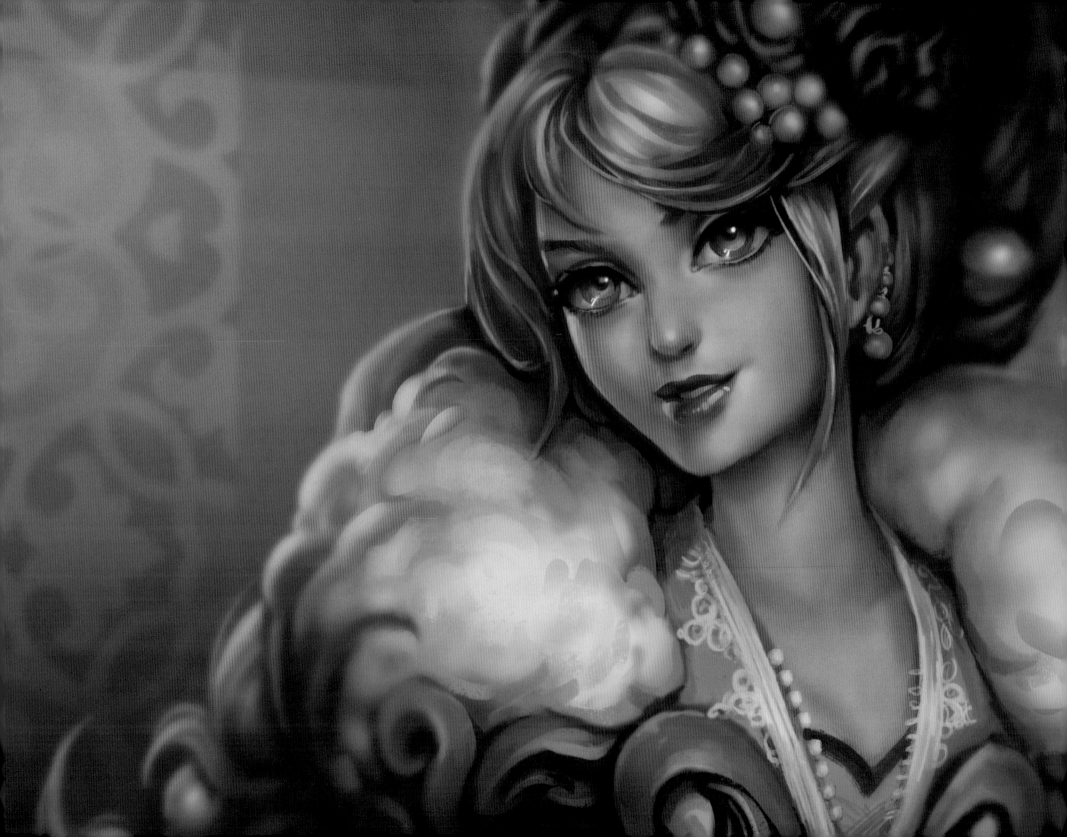

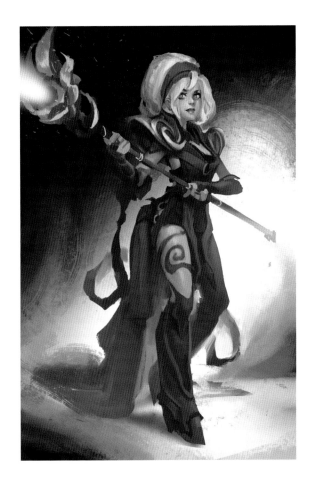

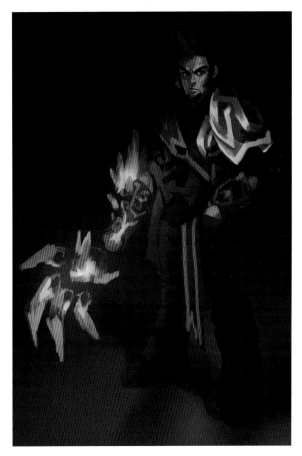

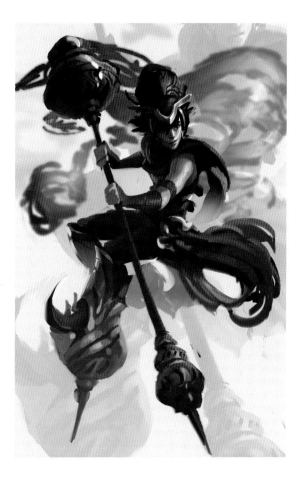

OUSSAMA AGAZZOUM

As a child I have spent my days running across the fields of Sidi Bou Othmane, with the images of Totoro in my mind. My childhood was one of imagination where I could see myself with characters from stories, enriching the urge to grow into a person who would be able to create such worlds for others to enjoy as I did. At the beginning I attempted to take electrical engineering as art was just a hobby, but I then quickly realized that a pen in one hand and a piece of paper in the other with my imagination as the ink was my true calling. Ever since, I have focused on enhancing skills through art school and training in video game art. I am now a character designer at Ubisoft.

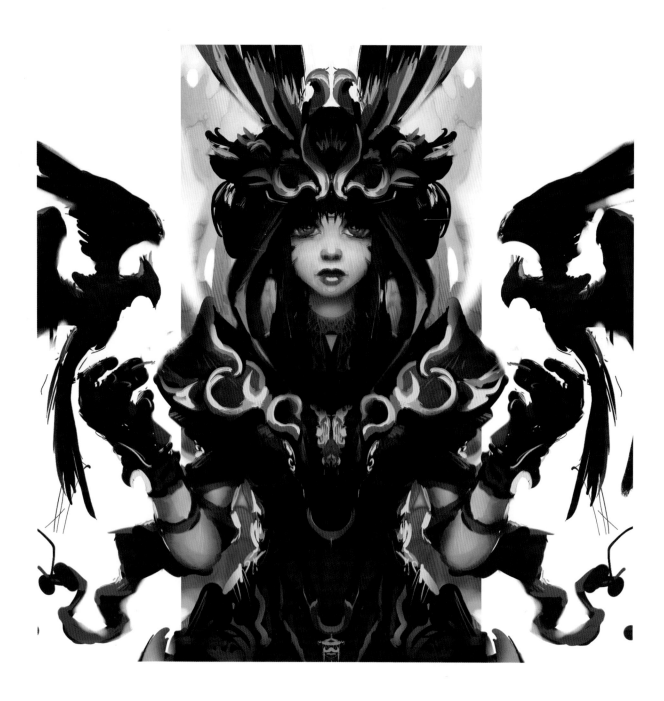

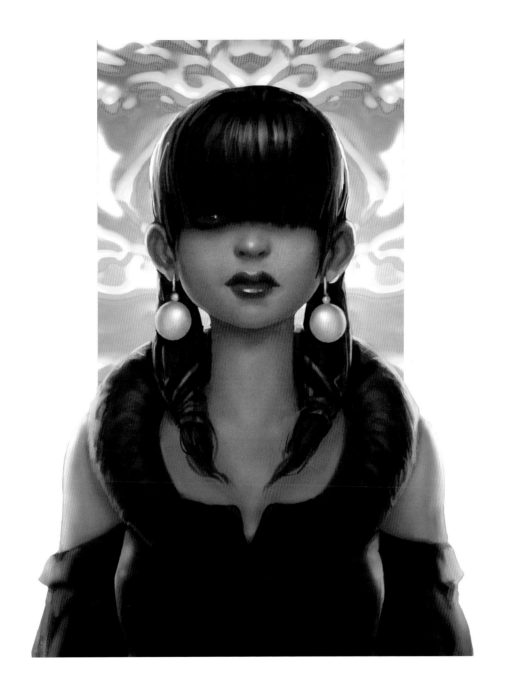

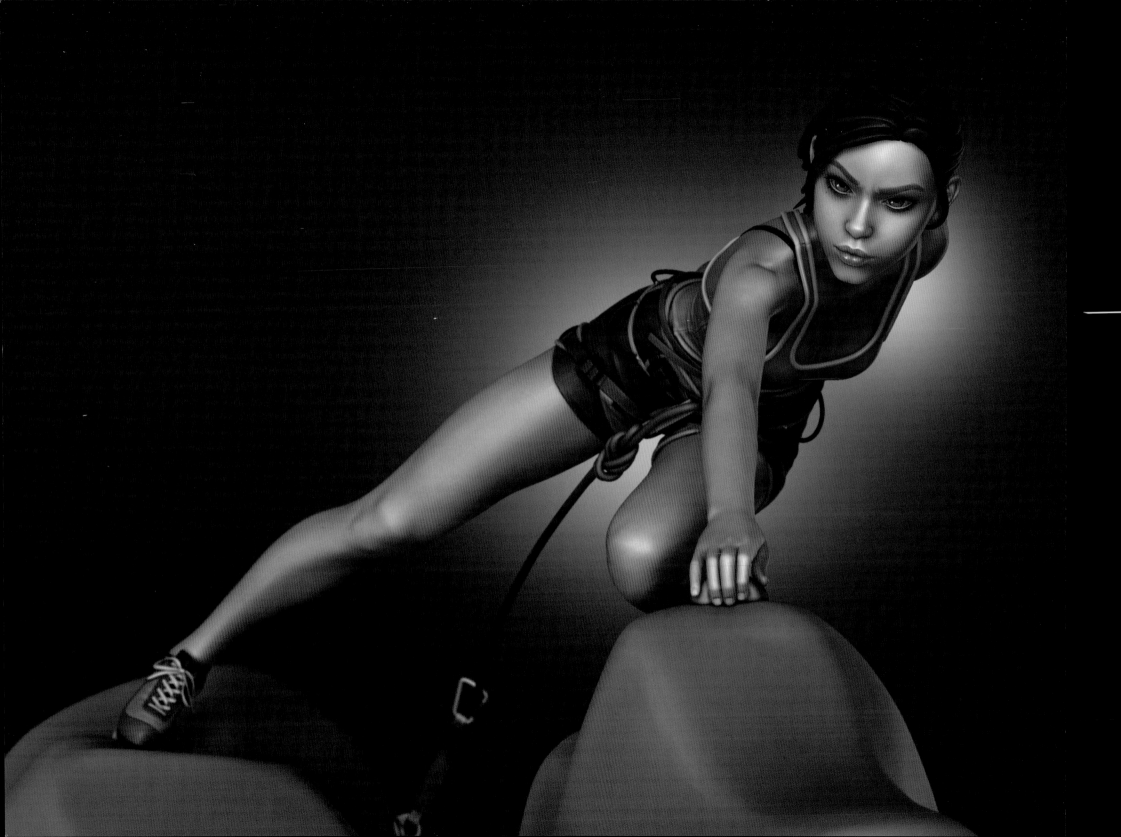

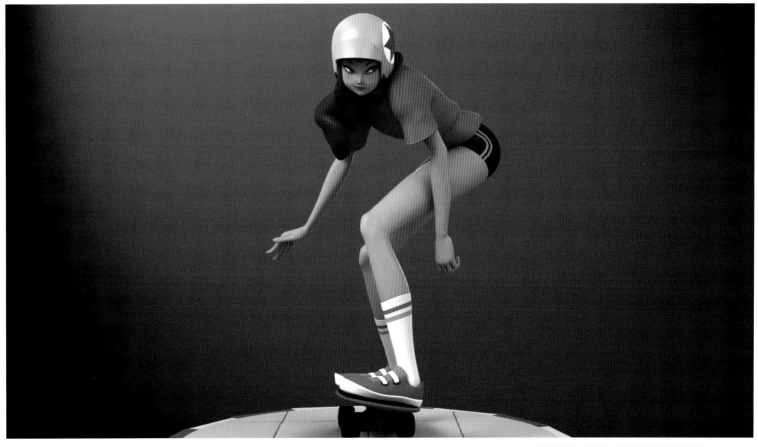

INSPIRED BY AND BASED ON THE CONCEPT BY ANNA CATTISH

RUSLAN BOULAD

I'm a 3D artist based in Jordan. I've been working professionally since 2008, mainly focusing on character creation and 3D modelling inspired by my love for video games. I come from a diverse family, and growing up in different countries has exposed me to a number of cultures that helped shape me both as a person and an artist.

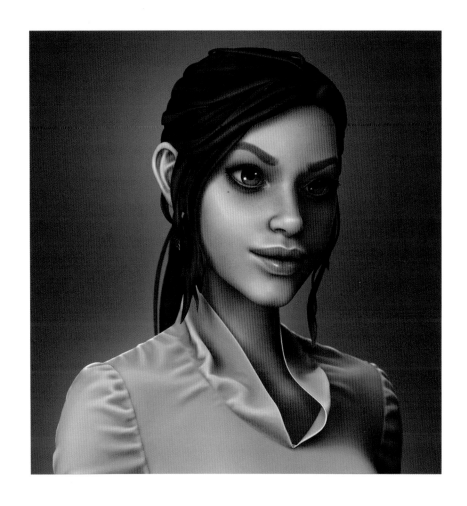

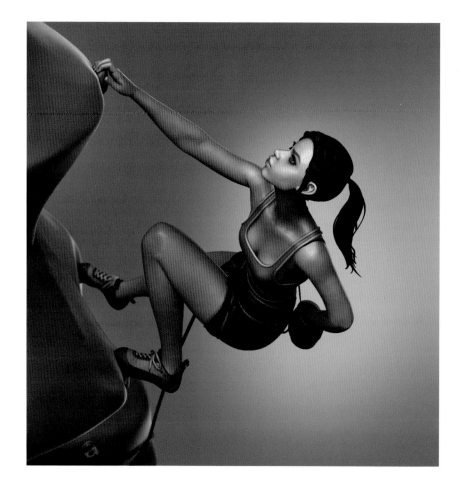

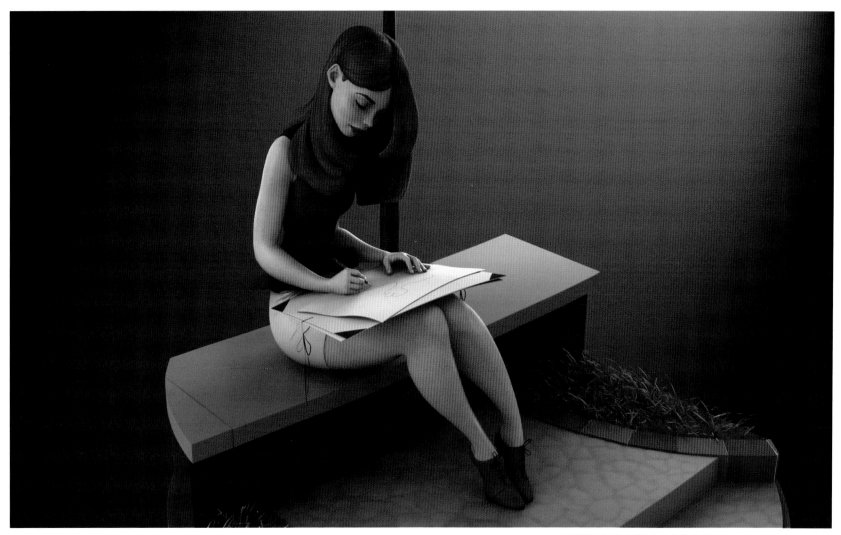

INSPIRED BY AND BASED ON THE CONCEPT BY DAEMION ELIAS GEORGE-COX

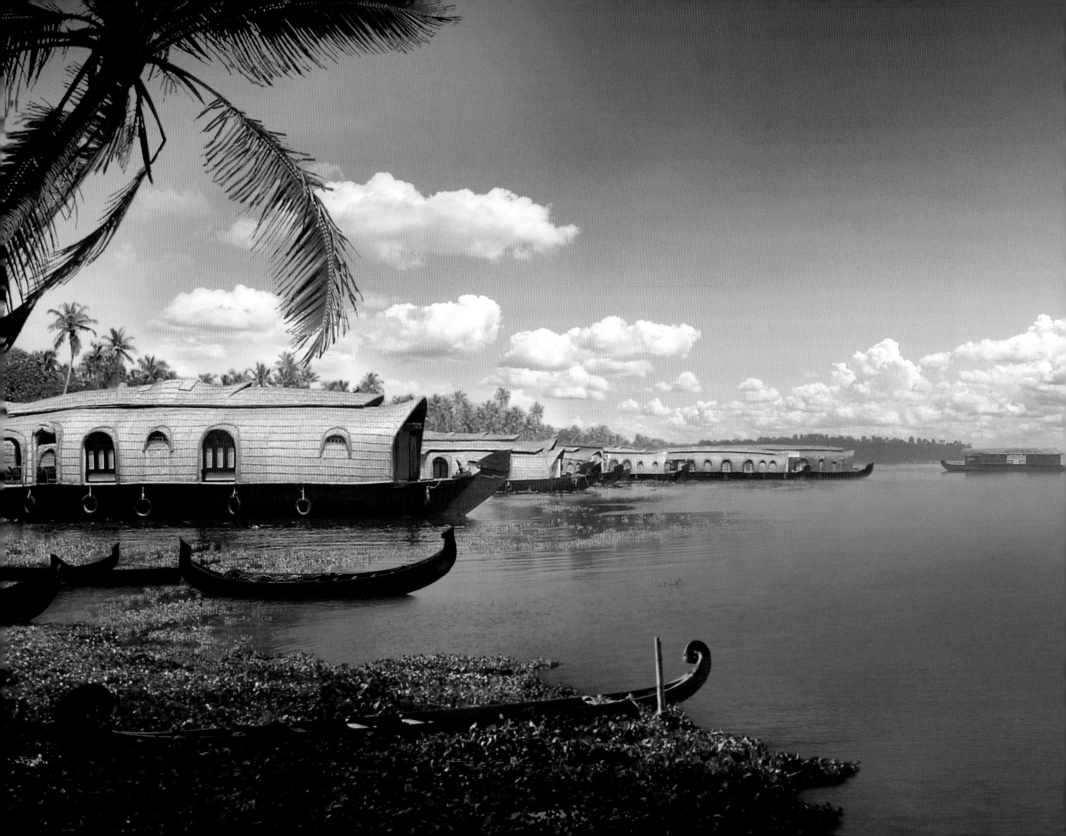

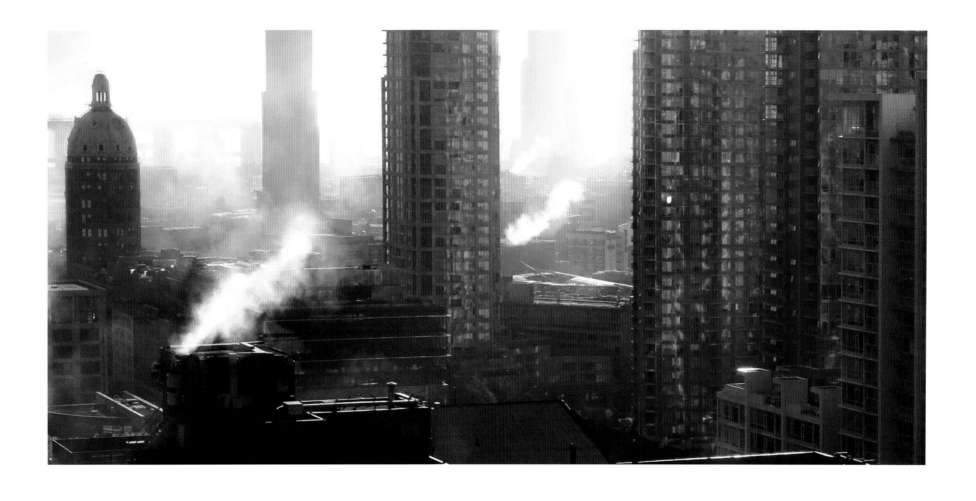

RAHUL VENUGOPAL

I am a digital compositor/matte painter with an immense passion for filmmaking and visual effects. Over the years I have had the opportunity to work on some fantastic projects ranging from corporate videos, commercials and feature films, in many countries such as Singapore, India, Bulgaria, Turkey, China, the United Kingdom, Canada and the United Arab Emirates. I'm big on travelling, and every adventure I've gone on has introduced me to a slew of new cultures, languages and customs.

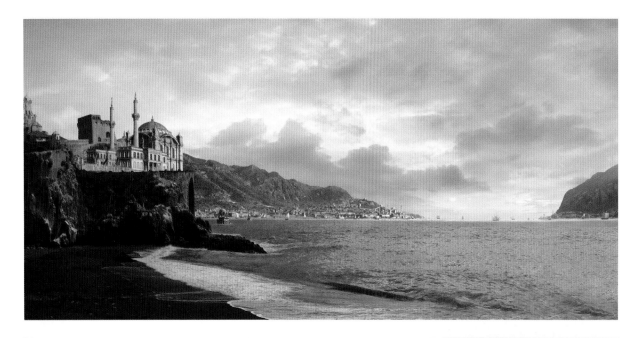

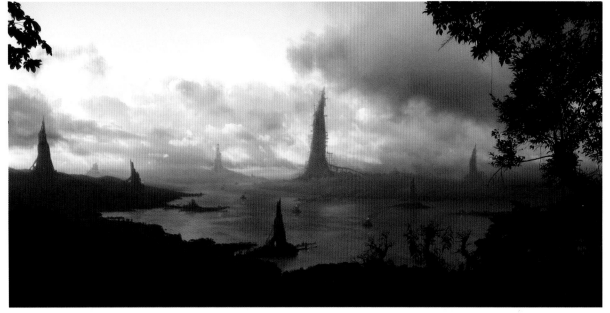

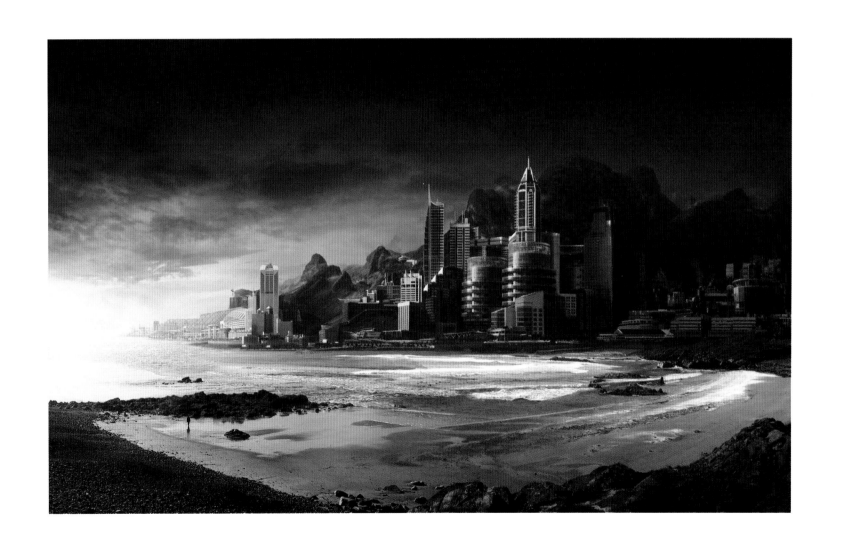

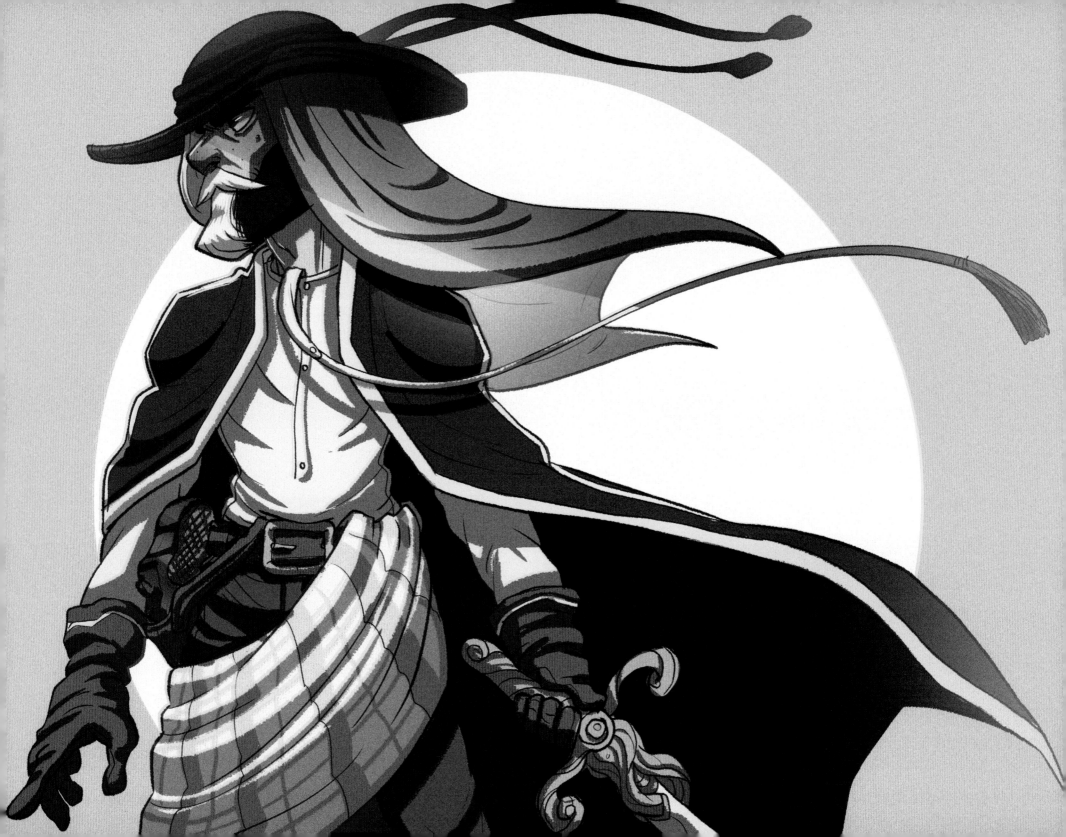

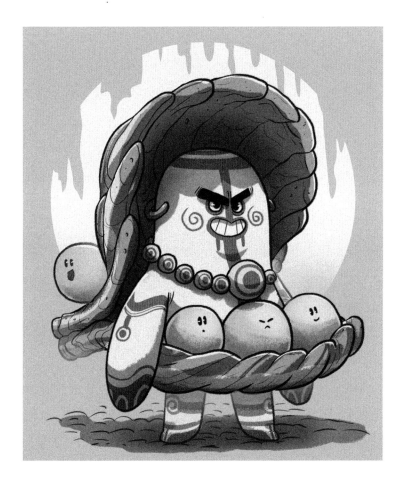

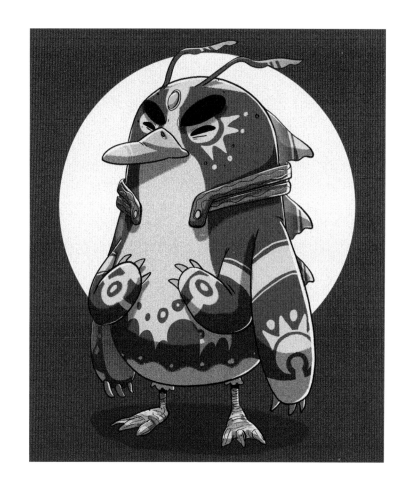

SHIHAB ALDEEN AL MUSHARAF

I'm a Sudanese author and illustrator based in Dubai. Between the years 2011 and 2012, I attended the Cartoon Network Animation Academy in Abu Dhabi, before graduating to work as an animator and a character and prop designer at Cartoon Network Studios Arabia. My portfolio includes the comic book titled Alaa the Bounty Hunter, the first to be produced through the twofour54 creative lab. Aside from comics and illustrations, my areas of interest include photography, print advertising and web design.

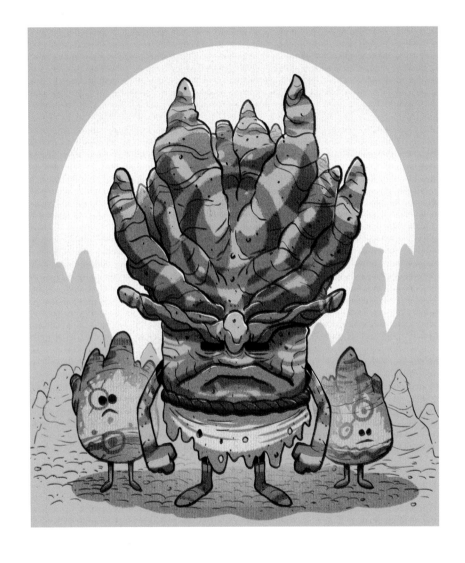

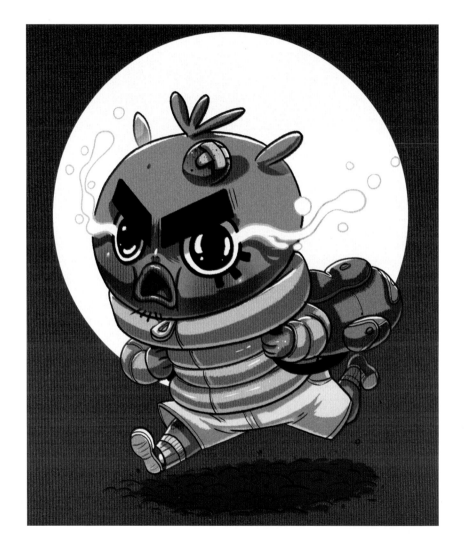

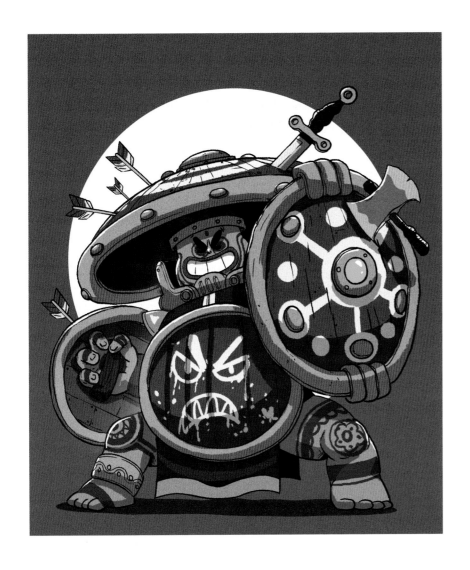

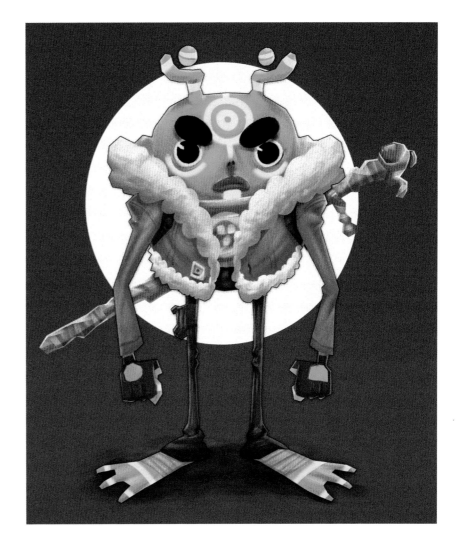

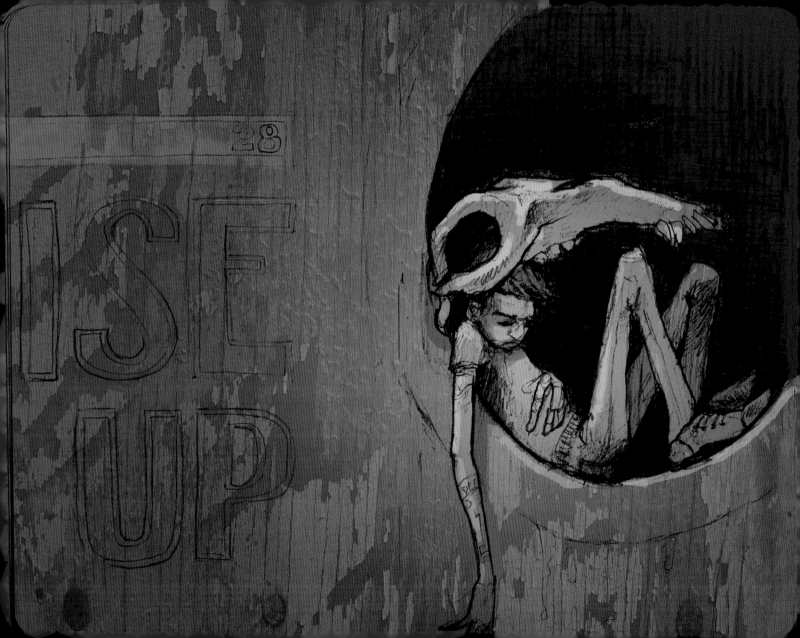

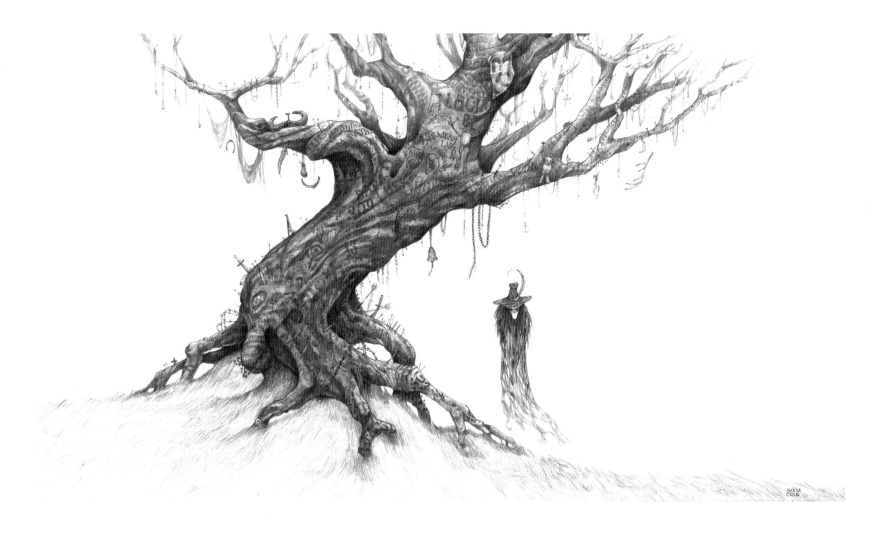

STEFAN MESSAM

I have been drawing for as long as I can remember. With a masters degree in design, majoring in illustration and visual narrative. I currently teach illustration and design at the College of Arts & Creative Enterprises at Zayed University in Dubai, UAE. I am also working on 'The Resurrection Lands', a graphic novel based in the realm of Purgatory. The first volume of a three-part series was published in April 2015. The work explores the boundaries of the sketchbook as a resolved aesthetic and cohesive visual narrative, and is a culmination of my many character studies.

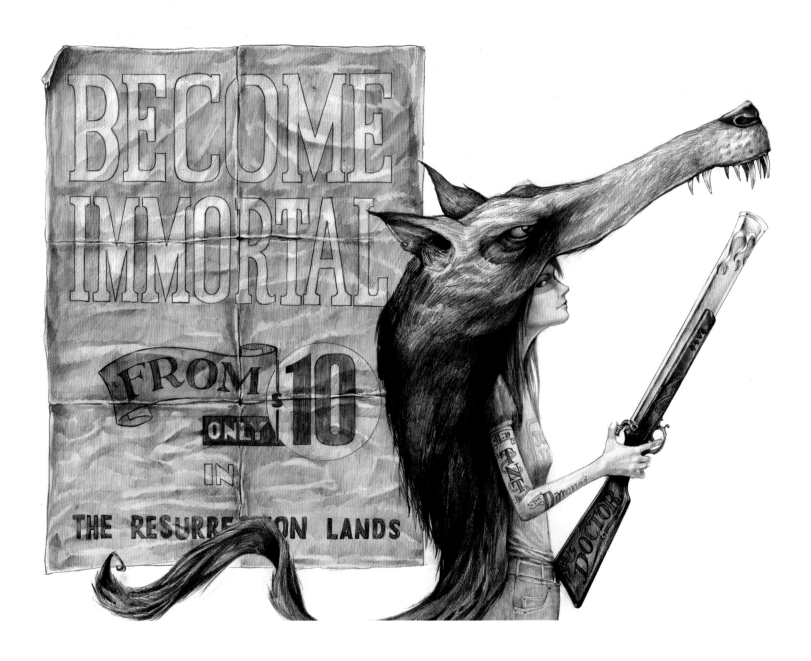

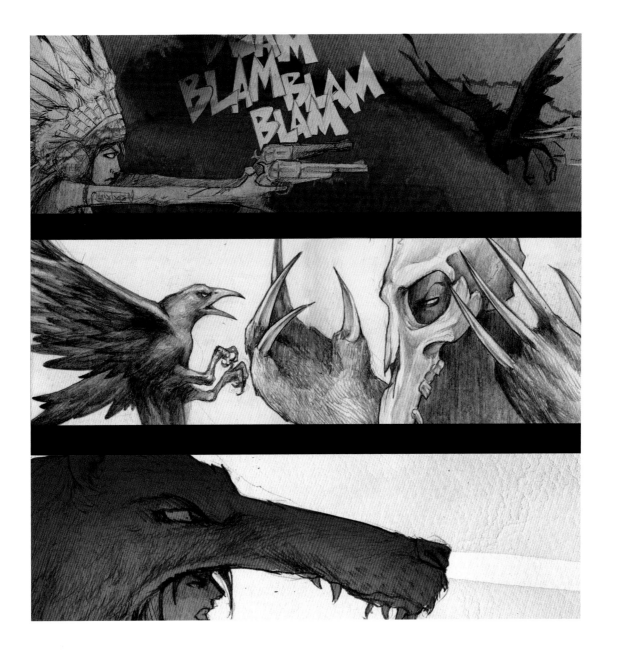

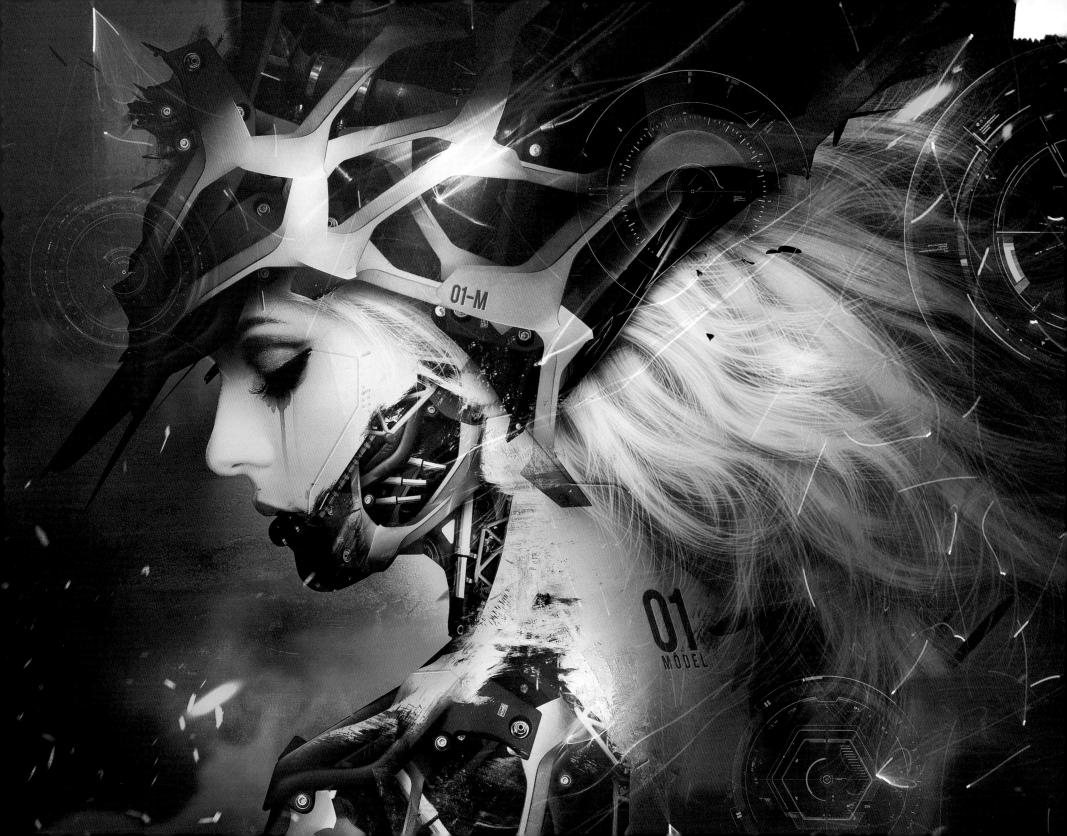

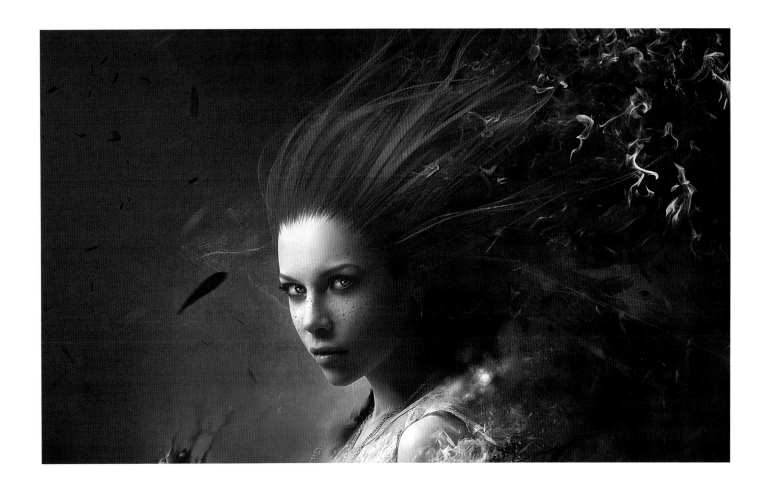

SOUFIANE IDRASSI

I'm a 25 year old digital artist from Morocco based in the UAE, currently working at Ubisoft Abu Dhabi. My areas of expertise include concept art, 3D sculpting/ modelling, character/creature design, graphic design, illustration and matte painting, and my illustrations mostly consist of dark and fantasy characters, through which I hope to tell stories without the need for words.

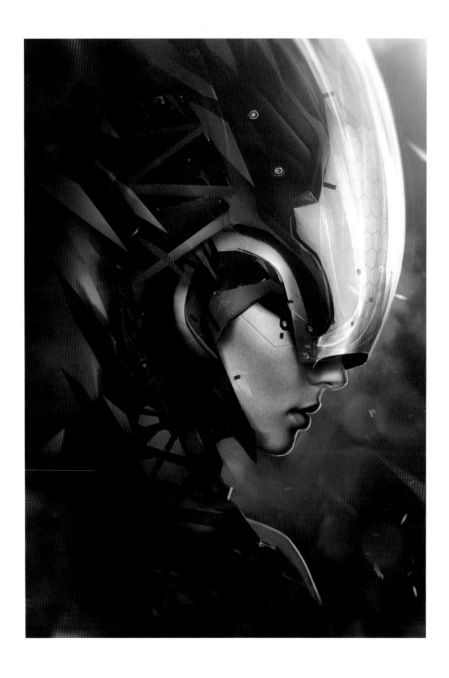

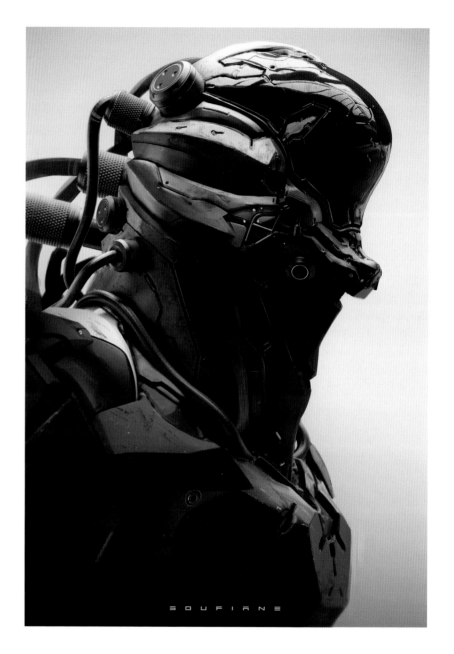

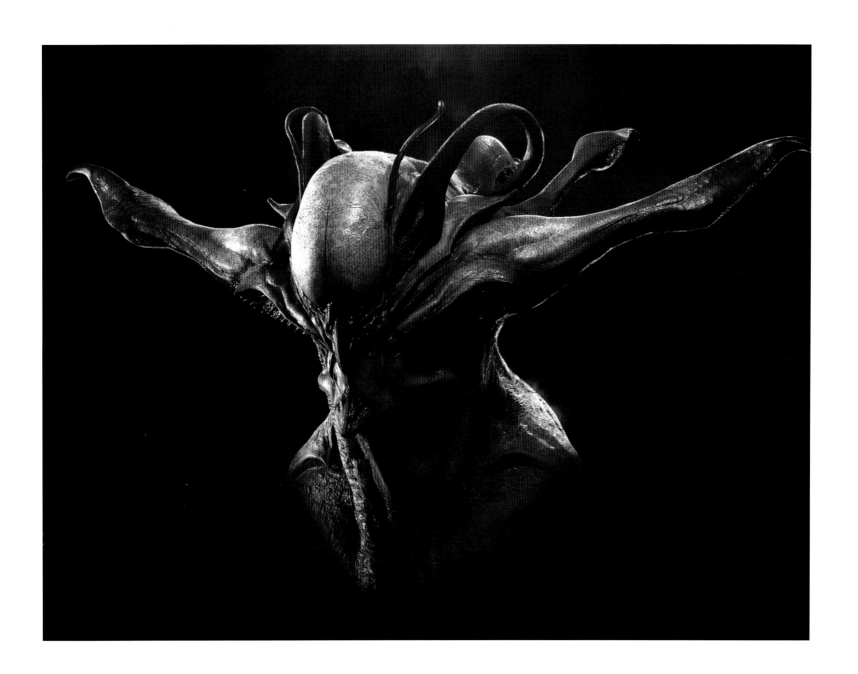

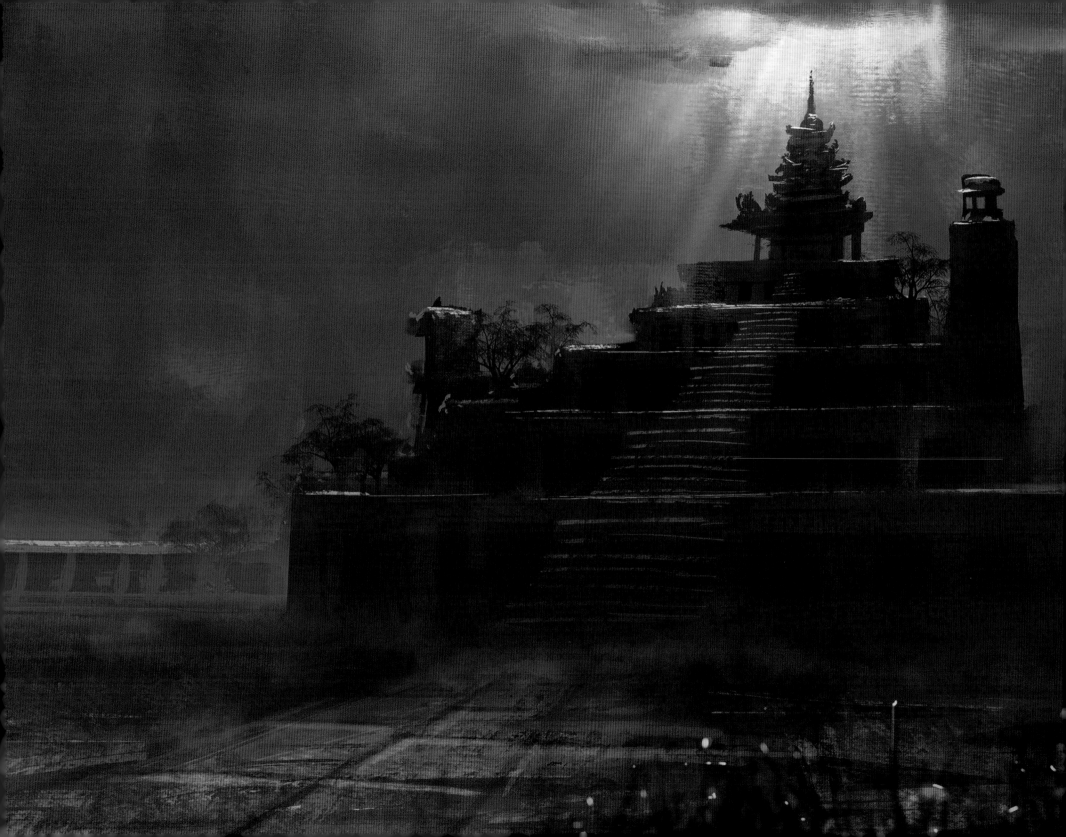

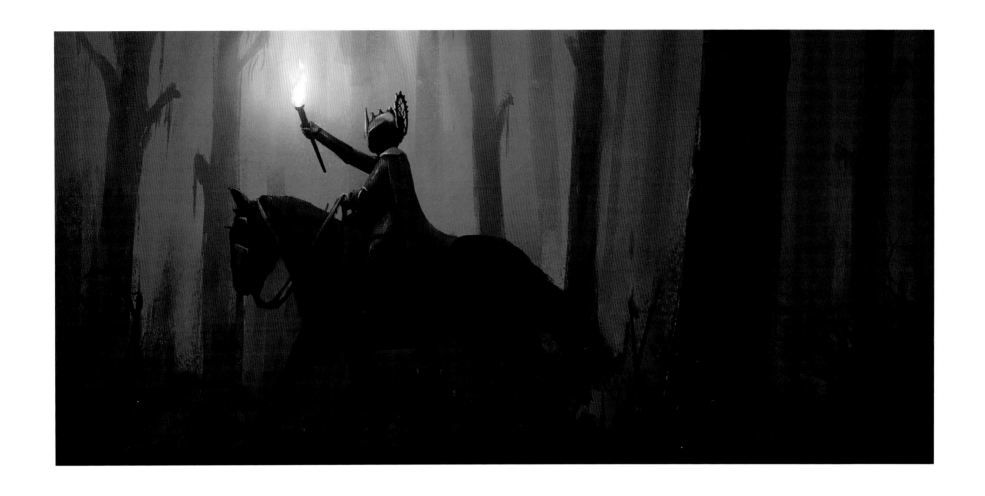

SURENDRA PRATAP SINGH RAJAWAT

After graduating with a diploma in animation from the MAAC Institute in New Delhi India, I began my career in the social and mobile game industry, which has led me to my current job as an environment concept artist for Ubisoft Abu Dhabi. My interests also include photography, cinematography and travelling.

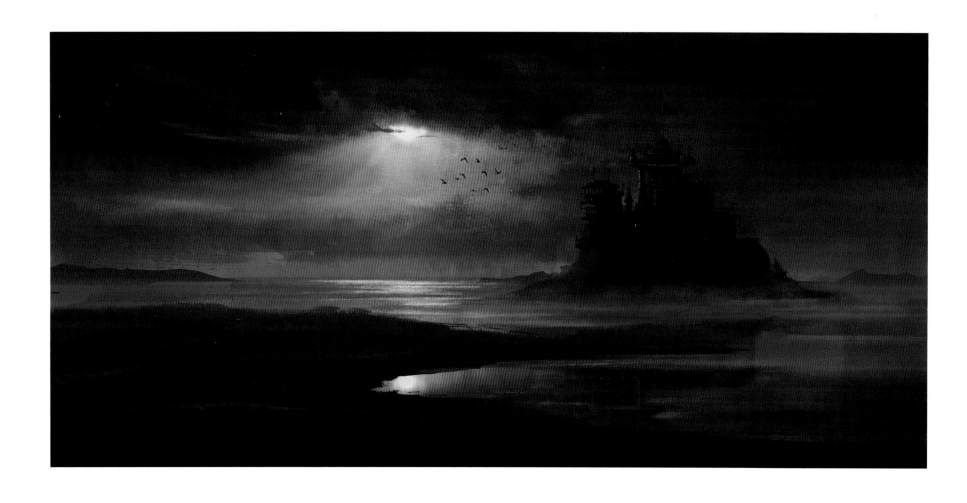

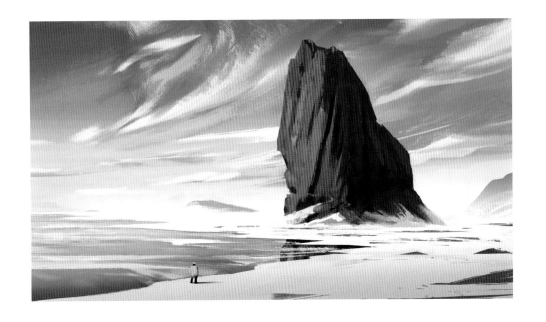

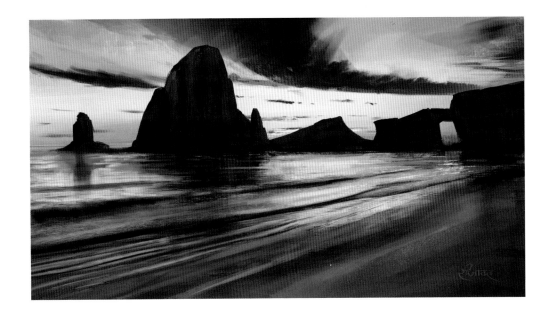

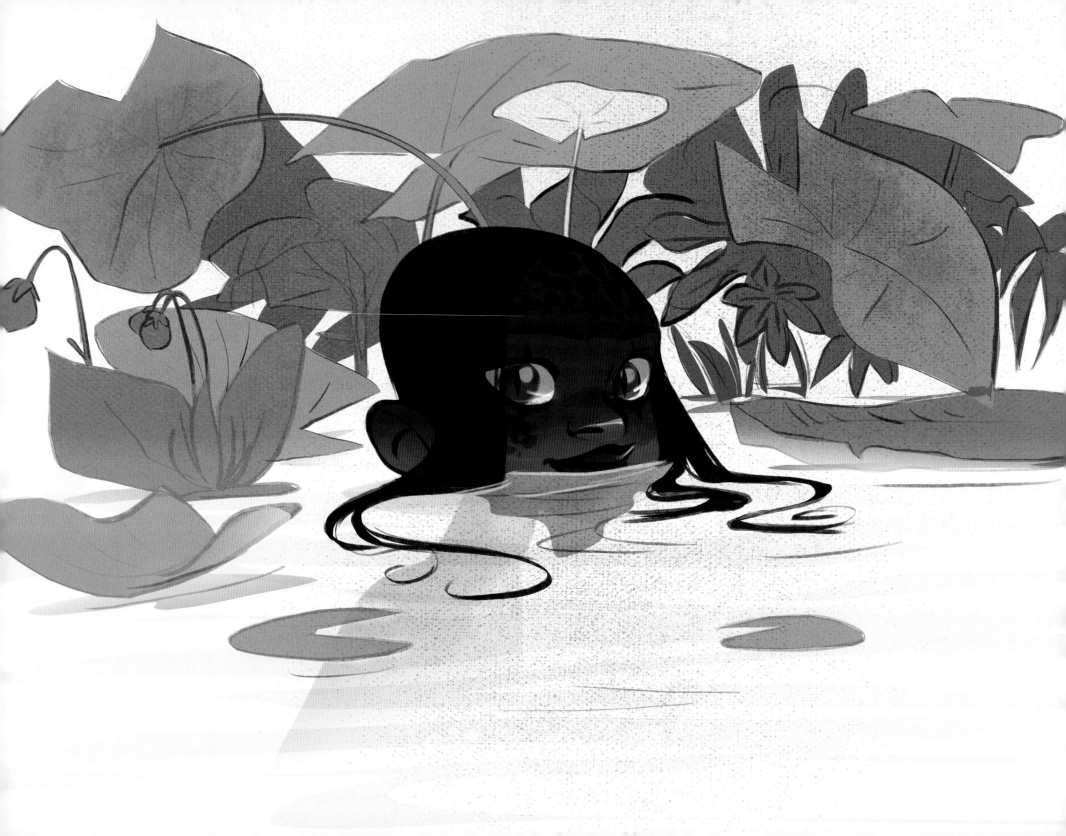

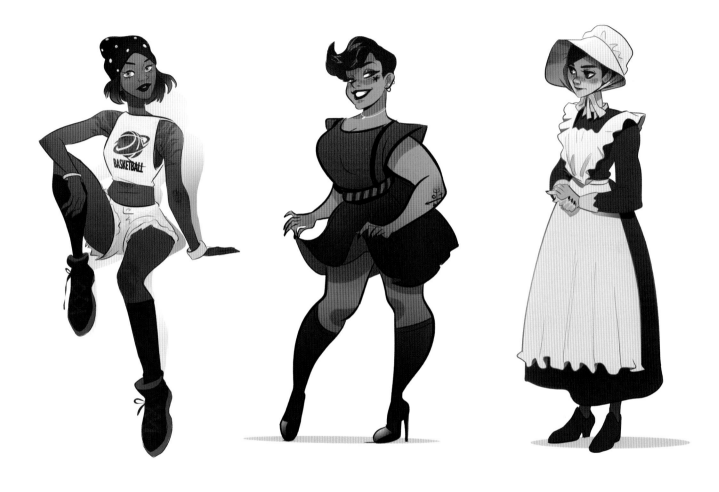

TARANEH KARIMI

I am a self-taught artist from Tehran with a huge passion for character design and illustration. You'll often find me bent over my Wacom, carefully bringing characters to life on my screen… otherwise I'll be either singing or losing badly in a video game against my hubby. I'm a fan of Studio Ghibli films, and I'm also currently working on my Kickstarter game, called "Lona: Realm of Colors".

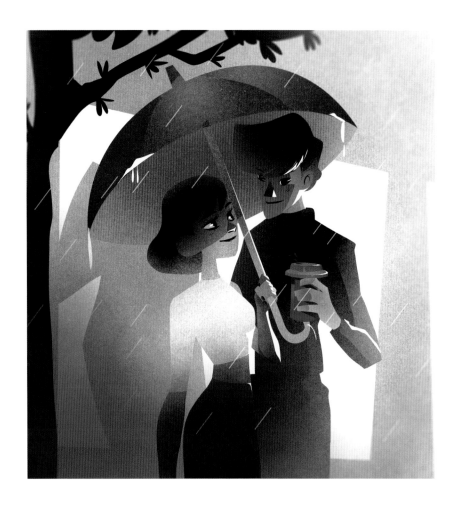

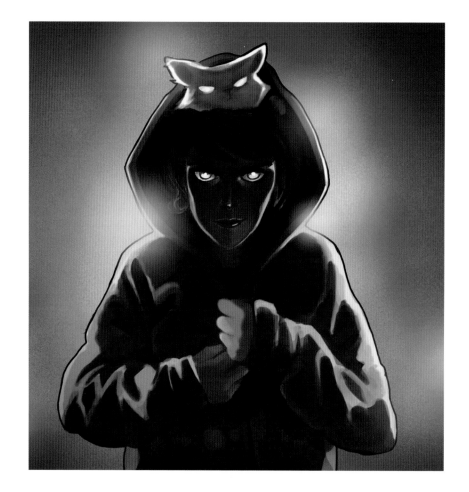

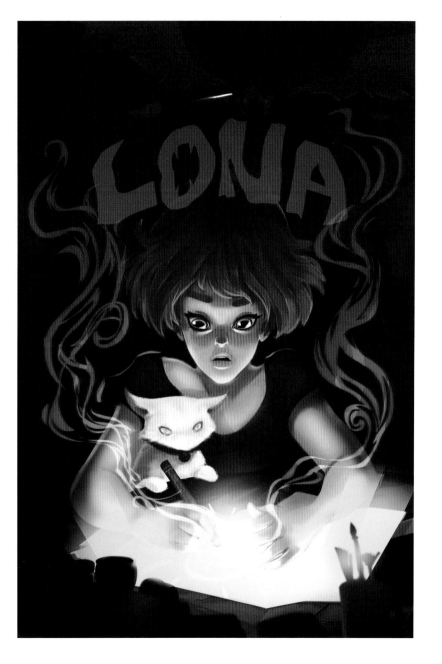

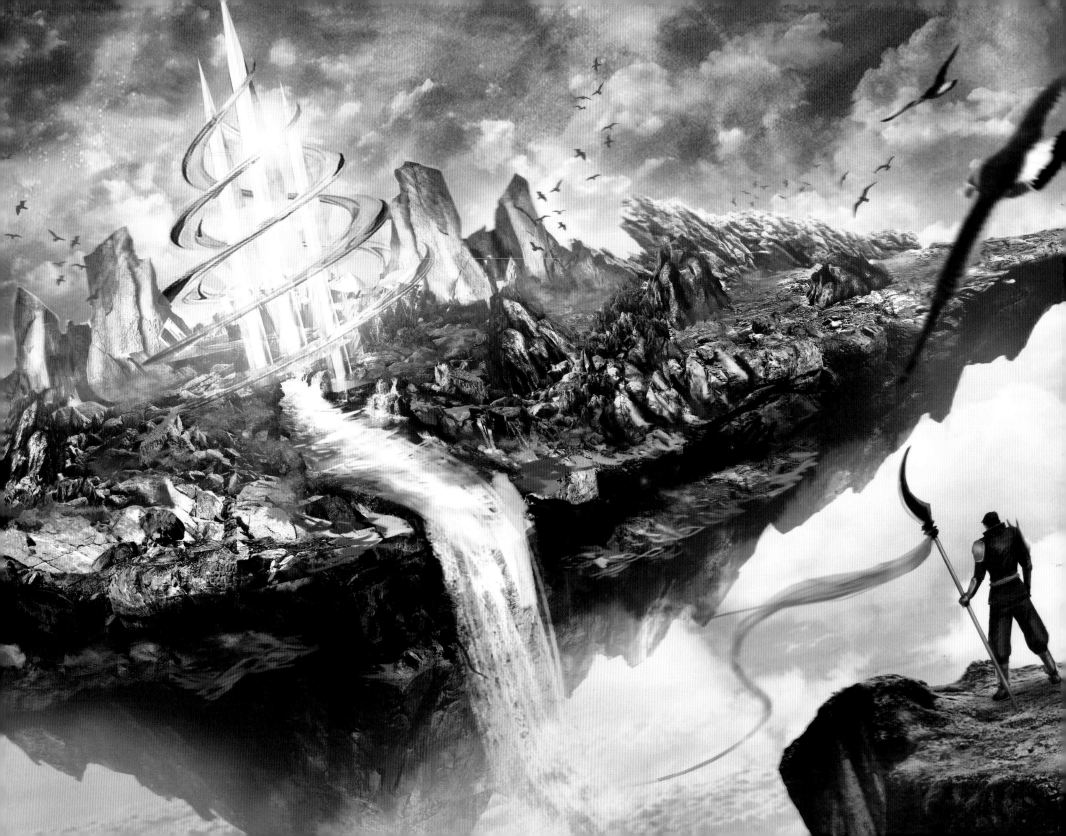

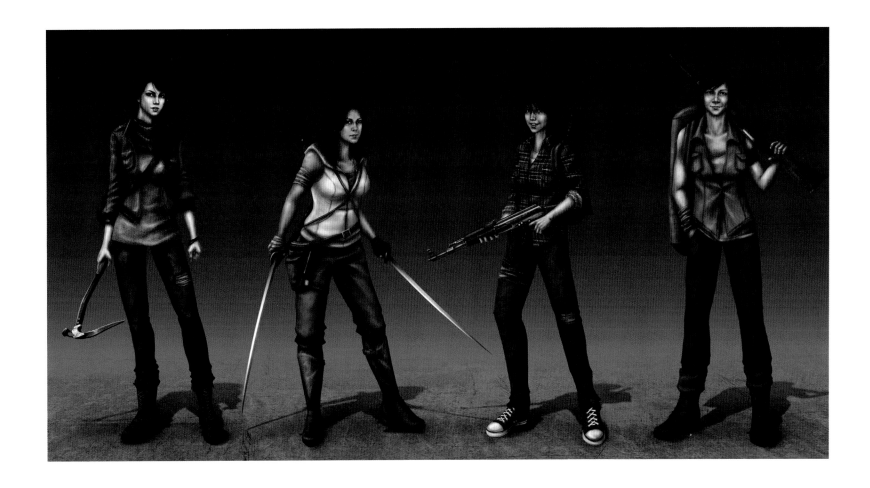

TRIXIA QUINZON

I was born in the Philippines in 1991. Growing up in an artistic family where all of us can draw, I was determined to be the best even though I was the youngest, fuelled by my love for Disney films, anime and video games. I am now in Dubai working as a concept artist and illustrator for a game and animation company.

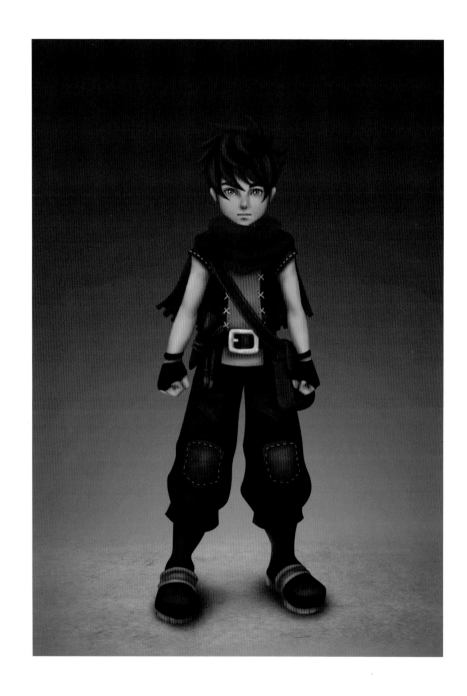

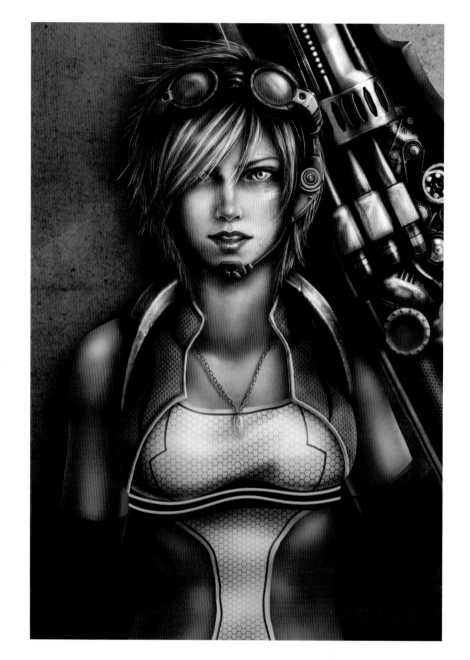

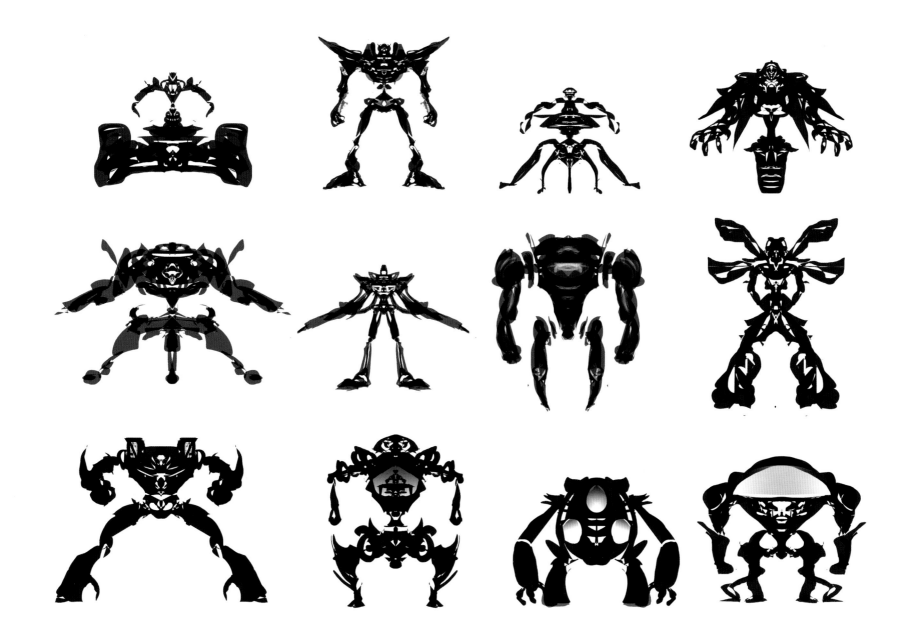

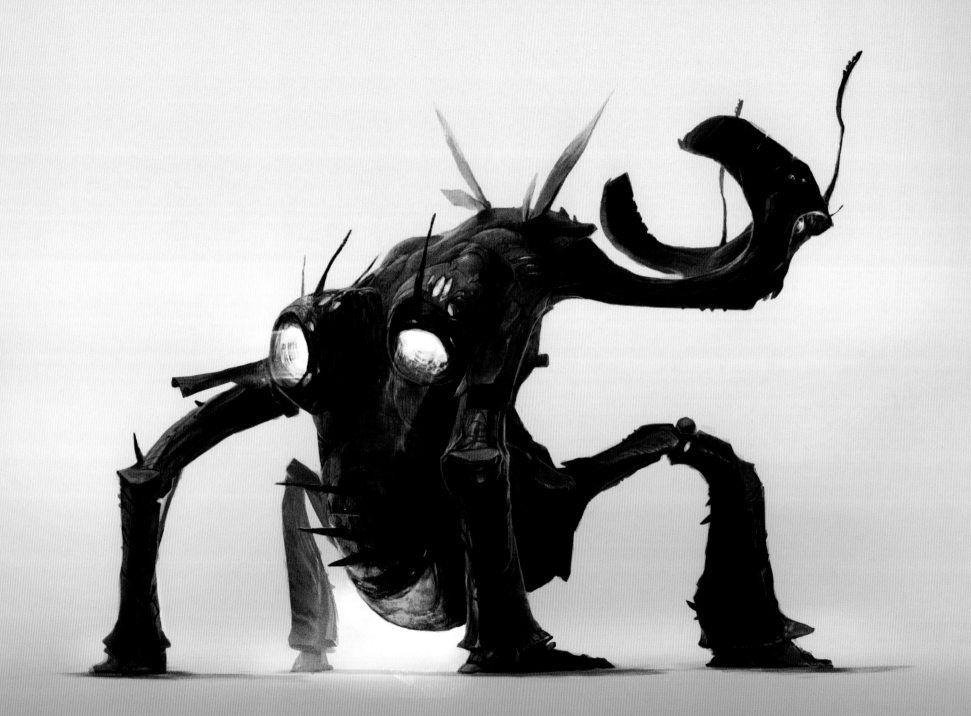

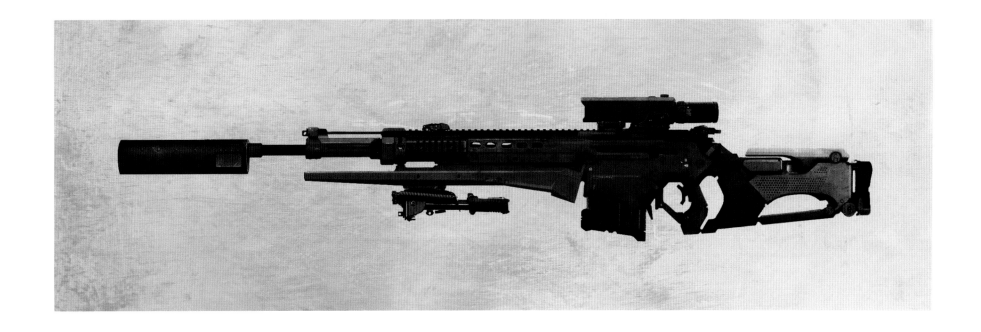

VADIM SVERDLOV

My name is Vadim and I'm a Russian concept artist. For a few years I worked as an art director at the "Gravity" firm, which specializes in post-production, but now I'm working with "Plarium" as a concept artist. In those few times when I achieve optimal working conditions (ie: a free moment and gushing inspiration) you will find me drawing, illustrating, sculpting and creating street art.

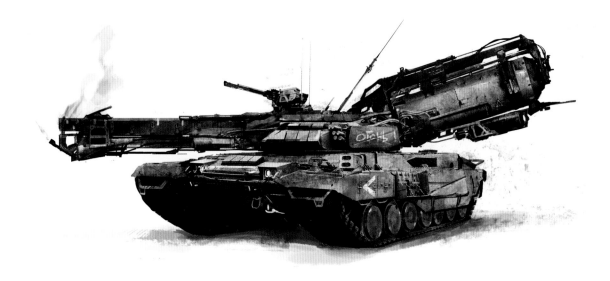

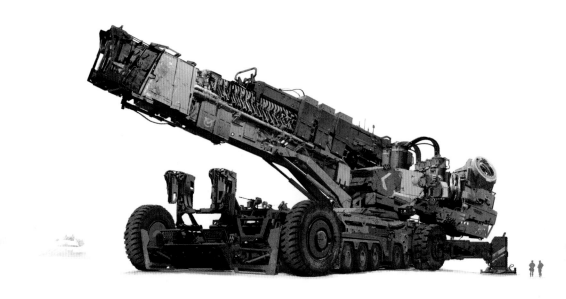

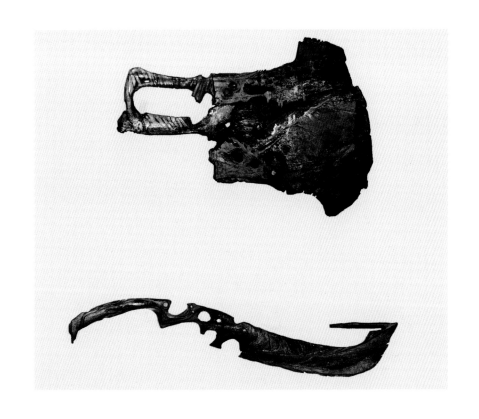

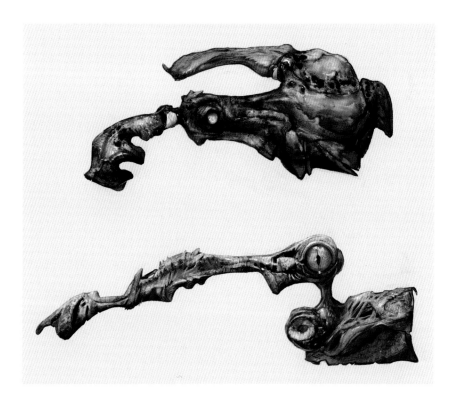

MEDIC.

DESIGN PROJECT BOXED MODULAR ROBOT
FOR 3D PRINTING WITH A TRANSPARENT BODY.

OBJECT CONSISTS OF SEVENTEEN PIECES OF
PRECAST. THE PROTOTYPE IS MADE OF
ESPECIALLY ROBUST VERSION OF THE
MATERIAL **SLA**
COMPLETE THE FIGURE COMES IN AS AN
PAINTED MODELS FOR ENTHUSIASTS. AND
ALSO IN FINAL FORM BY **SPRAYING** PAINTED
WITH ACRYLIC PAINT

project is completed on

12 % ◊◊◊◊◊◊◊◊◊▸▸

200 mm

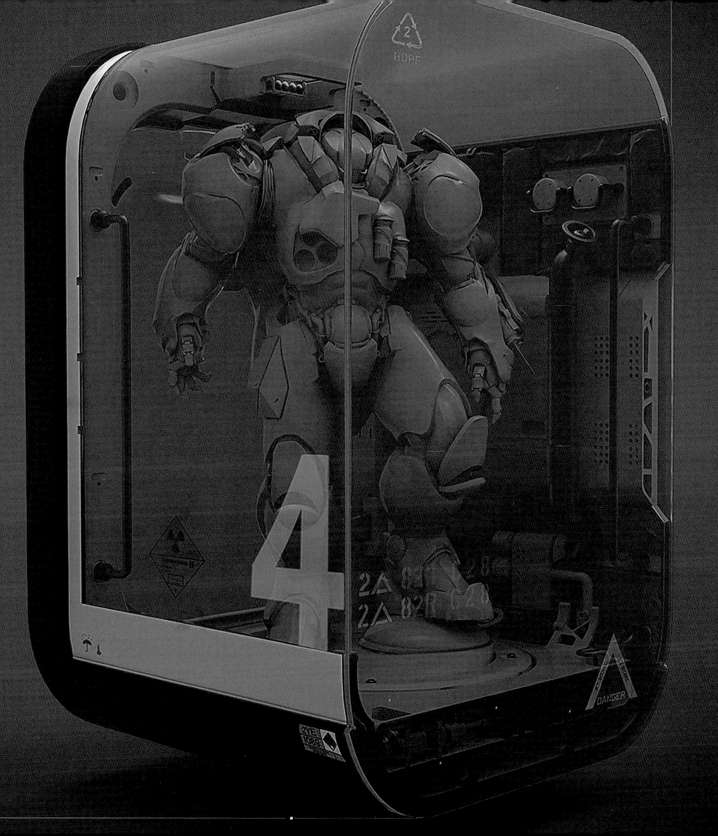

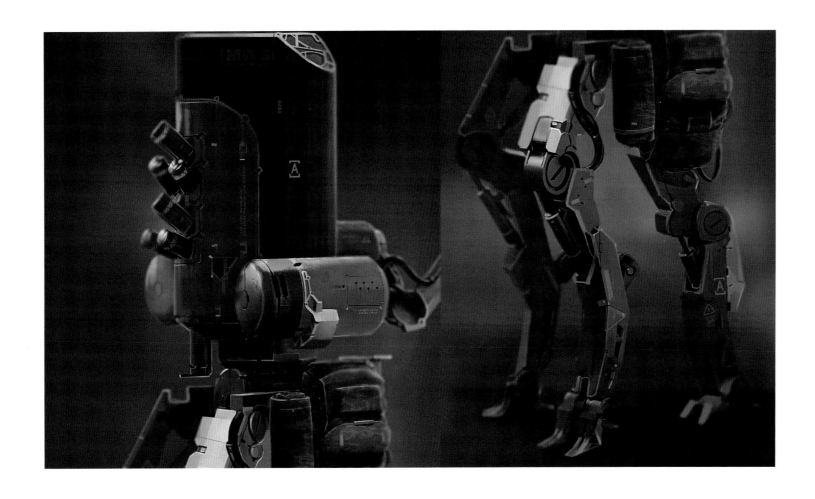

YURIY ROMANYUK

I'm a Russian artist currently based in Dubai, with experience of over 9 years in the computer graphics and games industry. I have worked with many big companies such as Gameloft and Sperasoft on amazing projects like Gunship Battle and Dragon Age: Inquisition; however, after being involved in such high-pace environments, I currently prefer to work on small-scale projects and develop my own artistic style. I am all but completely obsessed with sci-fi, and I'm also a fan of microscopic photography.

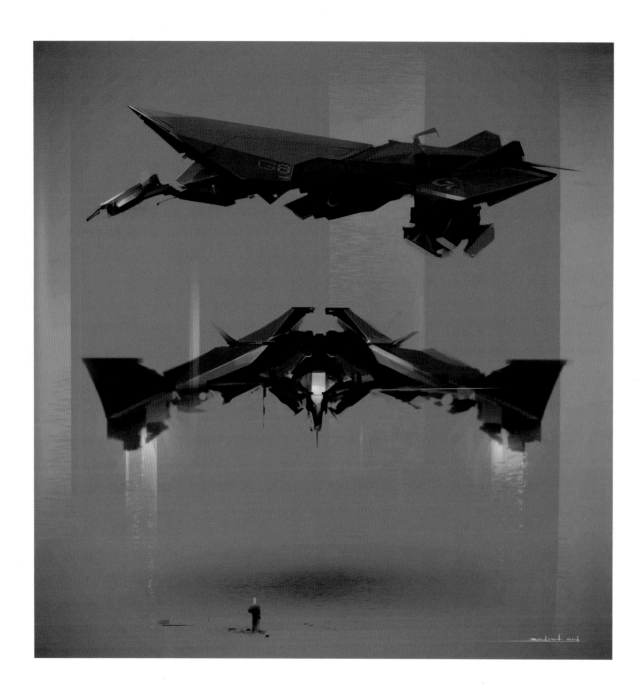

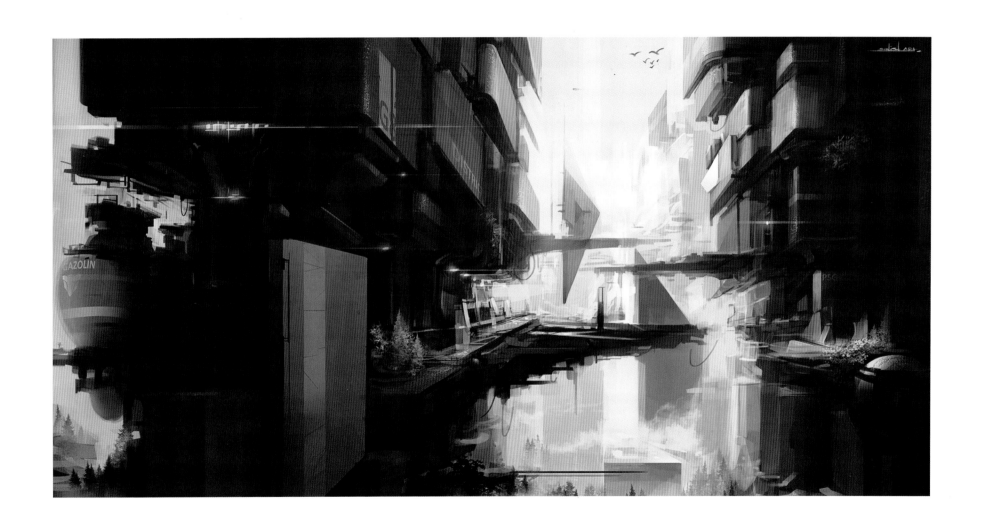

LIST OF ARTISTS

AHMAD ADEL BEYROUTHI
ahmadbeiruty2d@gmail.com
Pages:
6, 7, 8, 9
www.akuryux.blogspot.com

AHMAD MANAR LAHAM
manarlaham@gmail.com
Pages:
10, 11, 12, 13
www.manarlaham.blogspot.com

AHMED RAWI
ad.alrawi@gmail.com
Pages:
14, 15, 16, 17
www.artstation.com/artist/rawi

AHMED TEILAB
ahmedtealab247@gmail.com
Pages:
18, 19, 20, 21
www.artstation.com/artist/ahmedteilab

AZIM AL GHUSSEIN
azimgh@gmail.com
Pages:
22, 23, 24, 25
www.azimgh.com

AMEERA SHEIKH
ameera.m.sheikh@gmail.com
Pages:
26, 27, 28, 29
www.mikandii.com

BRANDON FERNANDES
Fernandes.brandon@gmail.com
Pages:
30, 31, 32, 33
www.n3tninja.com/portfolio

BENOIT FRAYLON
bfraylon@gmail.com
Pages:
34, 35, 36, 37
www.benoitfraylon.com

CASSANDRE BOLAN
Art@cassandrebolan.com
Pages:
38, 39, 40, 41
www.cassandrebolan.com

DANIEL MALLADA RODRIGUEZ
danimallada.ilustracion@gmail.com
Pages:
42, 43, 44, 45
www.danielmallada.com

ESLAM ABOSHADY
eslamaboshady_61@hotmail.com
Pages:
46, 47, 48, 49
www.artstation.com/artist/eslamashady

HICHEM ZARRAD
Zarrad.hichem@gmail.com
Pages:
50, 51, 52, 53
www.zarrad.deviantart.com

IBRAHEM SWAID
Ibrahem.swaid@gmail.com
Pages:
54, 55, 56, 57
www.holypixels.com

JOSHUA CORPUZ
joshcorpuzart@yahoo.com
Pages:
58, 59, 60, 61
www.artstation.com/artist/joshcorpuz

JOUMANA ISMAIL
joumana.ismaiel@gmail.com
Pages:
62, 63, 64, 65
www.behance.net/joumana

KHADIJA AL SAEEDI
Khadija.Alsaeedi@hotmail.com
Pages:
66, 67, 68, 69
www.behance.net/Dejayzjunk

KEREM BEYIT
kerembeyit@hotmail.com
Pages:
70, 71, 72, 73
www.kerembeyit.deviantart.com

MOHAMED AL SADANY
mohamed_alsadany@yahoo.com
Pages:
74, 75, 76, 77
www.behance.net/alsadany

MOHAMED ALI
mohamedali789@hotmail.com
Pages:
78, 79, 80, 81
www.3ali.deviantart.com

MUSTAFA LAMRANI
mustafalamrani3@gmail.com
Pages:
82, 83, 84. 85
www.mustafadesign.weebly.com

NAKA ISURITA
Naka474@gmail.com
Pages:
86, 87, 88, 89
www.nakarts.strikingly.com

OUSSAMA AGAZZOUM
White.leyth@gmail.com
Pages:
90, 91, 92, 93
www.white-leyth.com

RUSLAN BOULAD
ruslan.boulad@gmail.com
Pages:
94, 95, 96, 97
www.ruslik.artstation.com

RAHUL VENUGOPAL
rahulon@gmail.com
Pages:
98, 99, 100, 101
www.rkvfx.com

SHIHAB ALDEEN AL MUSHARAF
faroleeto@hotmail.com
Pages:
102, 103, 104, 105
www.shihabaldeen.tumblr.com

STEFAN MESSAM
stefan.messam@zu.ac.ae
Pages:
106, 107 ,108, 109
skkmdotnet.wordpress.com

SOUFIANE IDRASSI
soufiane.idrassi@gmail.com
Pages:
110, 111 ,112, 113
www.artstation.com/artist/cgsoufiane

SURENDRA PRATAP SINGH RAJAWAT
s.rajawat@live.com
Pages:
114, 115, 116, 117
www.rajawat.artstation.com

TARANEH KARIMI
taranehk66@gmail.com
Pages:
118, 119, 120, 121
alternative.artstation.com

TRIXIA QUINZON
trixiaquinzon@gmail.com
Pages:
122, 123, 124, 125
www.artstation.com/artist/trixdraws

VADIM SVERDLOV
haidak@gmail.com
Pages:
126, 127, 128, 129
www.behance.net/tipa_graphic

YURIY ROMANYUK
sadist.cg@gmail.com
Pages:
130, 131, 132, 133
www.romanyk.artstation.com

EPILOGUE

Authors: Ibrahem Swaid & Joumana Ismail
Artists biographies by Zeinab Alayan

Cover illustration by Ahmad Beyrouthi
Layout by Joumana Ismail
Designed in Dubai, United Arab Emirates

UDON STAFF

Chief of Operations: ERIK KO
Director of Publishing: MATT MOYLAN
Senior Producer: LONG VO
VP of Sales: JOHN SHABLESKI
Production Manager: JANICE LEUNG
Marketing Manager: JENNY MYUNG
Japanese Liaison: STEVEN CUMMINGS

EPILOGUE: ILLUSTRATION AND CONCEPT ART OF THE MIDDLE EAST

All artwork is © its respective owners.

Published by UDON Entertainment Corp.
118 Tower Hill Road, C1, PO Box 20008
Richmond Hill, Ontario, L4K 0K0 CANADA

www.UDONentertainment.com

First Printing: October 2017
ISBN-13: 978-1-772940-45-9
ISBN-10: 1-772940-45-3

Printed in China